INTRODUCTION

◆

I have long threatened to write a book called *Every Plant Tells a Story* based on my belief that for any plant species there is something interesting to say, perhaps about its adaptations for survival, its value to humans, its cultural significance, or its intriguing name. In a way, this is that book.

The special feature of the book is its innovative approach to displaying the stunning plant illustrations. The designers initially selected almost 200 historic paintings, mostly from the Georgian and Victorian eras, and usually based on backyard specimens. I had the pleasure of looking through these to select the best for the book.

This was a period when humans were seeking to establish dominion over nature, so garden artists often sought to paint excessively ornate and flamboyant specimens, just as their landscape colleagues over-romanticized the scenery they painted to make it look more rugged

and wild. I have chosen a few of these paintings to illustrate this aspect of horticulture, but mostly I have selected paintings that match the appearance of wild plants, and have tried to add interest to them by describing the lives of the plants they show.

I have minimized botanical terminology, but assume readers know that most flowers consist of showy, colorful petals, and outer sepals which are usually smaller, green, and form a protective sheath around the flower in bud. Collectively, sepals and petals are known as "perianth parts." The species are described as "herbs," which lack woody stems; "shrubs," which are low-growing bushy plants with woody stems; or "trees," which are straighter and taller. Unless otherwise stated, they are all "perennials," meaning they flower over several successive seasons. Ideas about the relationships between species are changing with new genetic techniques, but I have based family names throughout on *Flowering Plant Families of the World* (Heywood et al, 2007). Scientific names are the most recent I can find, not necessarily those used when the plant was painted.

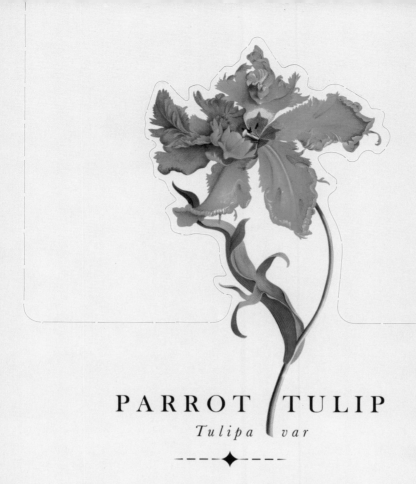

PARROT TULIP

Tulipa var

————◆————

FAMILY: *Liliaceae (Lily family)* **HEIGHT:** *12–24 in.*

FORM: *Herb* **NATIVE RANGE:** *Cultivation only*

It is difficult to recognize that this flamboyant flower, in a painting by the eighteenth-century German garden artist Georg Dionysius Ehret, is closely related to the garden tulips also featured in this book. Ehret labeled his painting simply *"Perroquet Rouge,"* meaning "red parrot" in French, from the fringed, feathery flowers. Gardeners still describe similar plants as "parrot tulips."

Most tulips have closed, bowl-shaped flowers and their name probably comes from the Persian word for "turban" because of this shape. A few have more open, spreading flowers, but no wild species matches the showiness of the variety in the painting. As with other members of the lily family, tulip

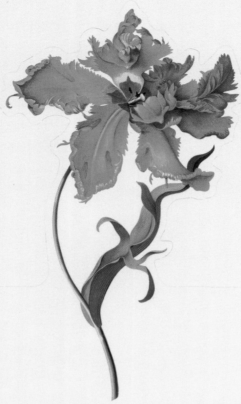

flowers do not have outer protective green sepals and colorful inner petals; instead they have six undifferentiated but colorful "perianth parts."

As soon as tulips became established in European gardens, breeders sought to improve on nature by selecting and propagating the showiest plants, then cross-breeding them with other attractive tulip species to produce larger and more colorful cultivars (cultivated varieties). Tulips are especially suited to this process because of their great variability and the unpredictable way in which markings on their flowers can change. We now know these variegated flower markings are caused by a virus. Garden artists sought out the most dramatic cultivars to celebrate in their paintings; hence, the florid and extravagant blossom in Ehret's painting.

In 1634, this enthusiasm for tulips triggered a speculative frenzy in Holland, known as "tulip mania," during which bulbs became so expensive that they were treated almost as a form of currency. In February 1637 the bubble burst, demand for tulips collapsed, and prices plummeted, leaving investors in desperate financial straits and the nascent tulip industry in ruins.

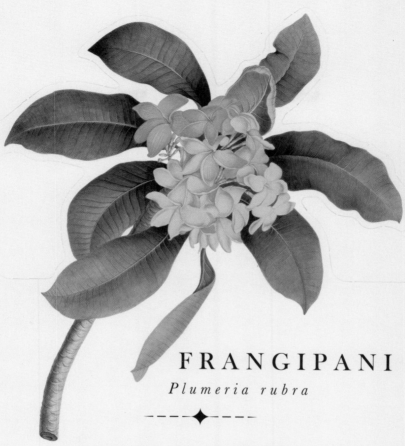

FRANGIPANI

Plumeria rubra

◆ – – – – – –

FAMILY: *Apocynaceae*
(Oleander family)
FORM: *Tree*

HEIGHT: *16–53 ft.*
NATIVE RANGE: *Central and*
South America

This beautiful painting by Georg Dionysius Ehret is labeled simply *Plumeria*, but there is no doubting that the distinctive flowers are those of Frangipani. The five overlapping petals are pinkish, pale yellow, or white, and suffused with yellow toward their center. It is the national flower of Nicaragua, known locally as *sacuanjoche* (meaning "flower with beautiful yellow petals").

The Frangipani tree has a short trunk, topped by spreading branches, which give its canopy a dense, rounded appearance. Its elliptical dark-green leaves are usually shed during the drier months of the year. When damaged,

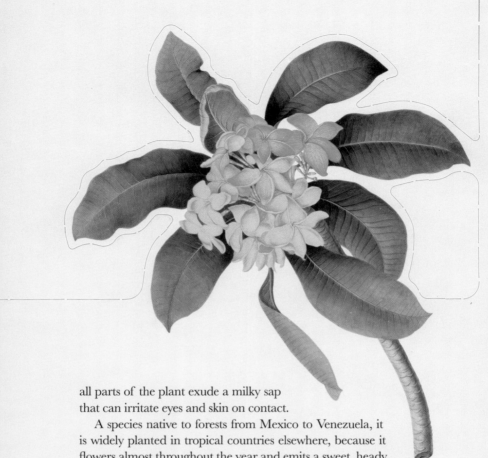

all parts of the plant exude a milky sap that can irritate eyes and skin on contact.

A species native to forests from Mexico to Venezuela, it is widely planted in tropical countries elsewhere, because it flowers almost throughout the year and emits a sweet, heady fragrance in summer. It is grown widely in the Caribbean, for example, and was introduced to the Hawaiian Islands in the 1860s.

Today, the rather waxy flowers of Frangipani play an important role in the culture of Hawaii. They often feature in the flower garland, called a *lei*, presented to visitors on arrival or departure as a symbol of friendship. In 2006, over 12 million flowers were cultivated commercially in the islands for this purpose.

Frangipani is named after a parfumier of the noble Italian Frangipani family, who developed a perfume from the flowers. The name comes from *frangi* ("breaking") and *pani* ("bread"), celebrating the family's distribution of bread during times of famine. The genus name *Plumeria* honors the seventeenth-century French botanist Charles Plumier, who was one of the first to explore Central America.

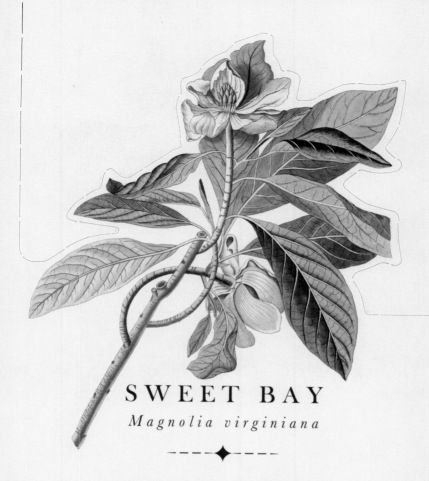

SWEET BAY

Magnolia virginiana

❖

FAMILY: *Magnoliaceae* **HEIGHT:** *33–92 ft.*

FORM: *Tree* **NATIVE RANGE:** *Eastern US*

Sweet Bay, sometimes called Sweetbay Magnolia, was known as *Magnolia glauca* at the time of this painting. It is a shrub or small tree found in the eastern United States from Florida to Long Island, New York, and is remarkably variable across its range. In the south, where winters are milder, it usually has a single trunk and evergreen leaves. In colder climates in the north of its range, it is deciduous, shedding its leaves before winter, and has multiple trunks, perhaps as a protection against gales. The southern single-trunked trees are taller. The largest known specimen, from Union County in Arkansas, reached a height of 92 feet, with a trunk diameter of 5 feet.

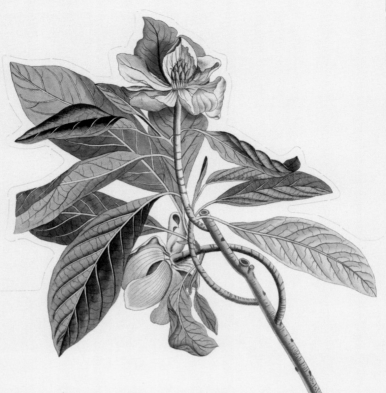

Fossils show that magnolia trees, scarcely different to modern ones, were growing 100 million years ago and were formerly much more widespread in the northern hemisphere. Magnolia flowers typically consist of two or three whorls of colorful "petals," although technically these are "tepals" because the outer ones are greenish and sepal-like, without any clear-cut distinction between sepals and petals.

The cup-shaped flowers of Sweet Bay have between 6 and 15 creamy-white tepals, producing a vanilla-like scent that can sometimes be detected from several hundred yards away. The fruit contains a cluster of black seeds, covered in a fleshy red coat. Various bird species eat these fruits, digest the red coating, and disperse the seeds in their droppings.

Sweet Bay is widely cultivated. It was the first magnolia known in Europe, having been collected in the United States by the English botanist and missionary John Banister and taken to England around 1678. Many deciduous and evergreen cultivars are grown in gardens, as well as hybrids with other magnolia species.

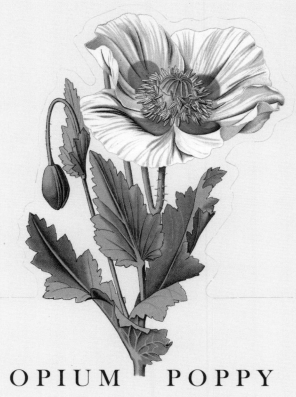

OPIUM POPPY

Papaver somniferum

— — — ◆ — — —

FAMILY: *Papaveraceae*
FORM: *Herb*
HEIGHT: *6–60 in.*
NATIVE RANGE: *Western Mediterranean*

There is a good chance that even the most well-behaved readers of this book will have recently consumed the products of Opium Poppy. The plants, under the more salubrious name of Blue Poppies, are grown quite widely in Britain and elsewhere in Europe for poppy seeds, which are used by the baking industry on and in breads and cakes. Oil from the seeds also goes into products as diverse as salad dressings and paints.

Various alkaloids are found only in this species and nowhere else in the natural world. These include codeine, a mild analgesic used against headaches and cold symptoms, and the much stronger painkiller morphine.

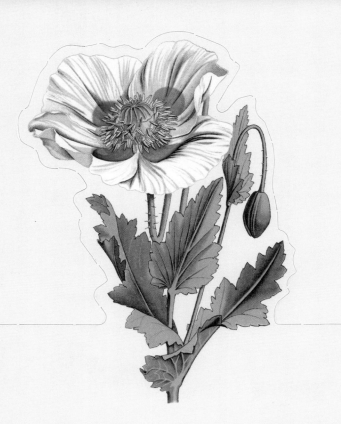

In 1898, the highly addictive drug heroine was first synthesized artificially from morphine, and this was sold legally in North America as a cough suppressant until 1917. Today, heroine is mainly produced from poppies grown in Afghanistan, where the stronger sunshine produces greater quantities of the opiate drugs.

Plants grown in cooler parts of Europe have much lower levels of opiates, and red- or white-flowered cultivars, sometimes with double petals, have become popular backyard ornamentals. These need to be regrown from seed each year because, rather remarkably for its size, Opium Poppy is an annual, meaning it grows from seed, flowers, sets seed, and dies within one year. To ensure a good chance of dispersal, each fruit capsule produces at least 6,000 seeds.

The species probably originated in the western Mediterranean, having been cultivated there for at least 6,000 years. The Greeks valued the plant as a sleep inducer (hence *somniferum*), and cultivated seeds have been found in Sussex in England, in gravel deposits dating from the Late Bronze Age, 3,000 years ago.

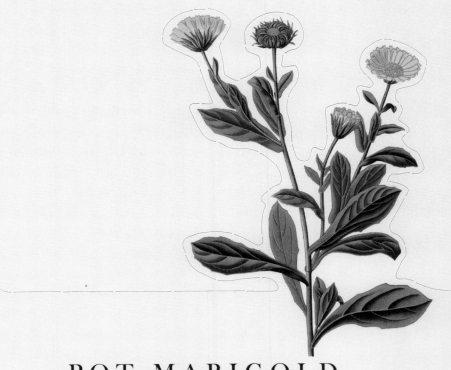

POT MARIGOLD

Calendula officinalis

--- ◆ ---

FAMILY: *Asteraceae (Daisy family)* **HEIGHT:** *8–20 in.*

FORM: *Herb* **NATIVE RANGE:** *Southern Europe?*

O*fficinalis* in the scientific name (meaning "of the shop" in Latin) alerts us that this is one of several species in this book that were formally grown and sold by herbalists for a variety of medicinal uses. Indeed, it has been cultivated for so long and so widely that it is difficult to tell its natural origins, although it most probably was a wild plant in southern Europe. The first record of it in British backyards dates from AD 995.

This is "Pot Marigold," because it was often grown in pots (not due to a more dubious connotation!). It is still a popular garden ornamental in temperate regions of the world, despite generally being

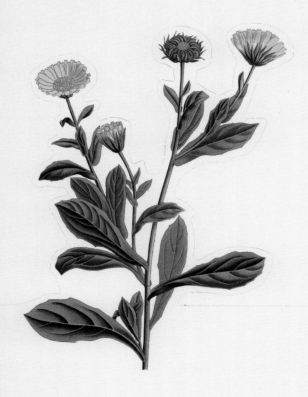

a fast-growing annual species which completes its lifecycle within a few months so needs to be grown afresh from seed each year.

It belongs to the Daisy family, so what we commonly regard as flowers are, in fact, made up of numerous small individual flowers (called florets). The massed florets that make up the central disc are tubular in shape, yellow or brownish, and functionally male, producing only pollen. The outer flowers are female and fertile, with strap-shaped lobes that form the ring of orange or yellow "rays," like petals. The flowerheads can be harvested in summer, and the dried "ray florets" then used as food coloring or as a garnish in salads. The flowers are visited and pollinated mainly by flies.

Marigold's therapeutic properties also lie primarily in its dried ray florets, which contain resins and other chemicals that are strongly antiseptic as an antifungal, antibacterial, and antiviral treatment. It is used to assist the healing of wounds, against minor burns and sunburn, and as a treatment for chilblains.

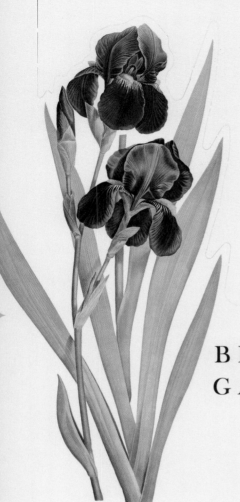

BEARDED OR
GARDEN IRIS

Iris germanica

- - - ◆ - - -

FAMILY: *Iridaceae (Iris family)*
FORM: *Herb*
HEIGHT: *24–48 in.*
NATIVE RANGE: *Eastern Mediterranean?*

Widely grown in backyards, this handsome iris also turns up regularly as an escape (a plant that has spread from cultivation to the wild) in wast-ground, waysides, and abandoned backyards around Europe, including southern Britain. Its wild origins are unknown; it may be native to the eastern Mediterranean region, or it may originate from garden hybridization. When dug up by gardeners, it is able to survive through its stout, spreading rhizome (underground stem) and tough roots.

Its inflorescence typically has two to four flowers, which are bluish-violet

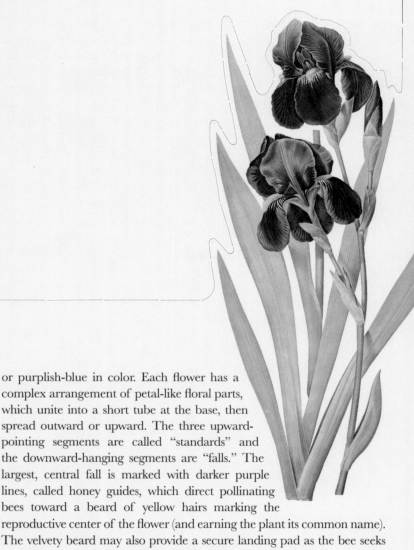

or purplish-blue in color. Each flower has a complex arrangement of petal-like floral parts, which unite into a short tube at the base, then spread outward or upward. The three upward-pointing segments are called "standards" and the downward-hanging segments are "falls." The largest, central fall is marked with darker purple lines, called honey guides, which direct pollinating bees toward a beard of yellow hairs marking the reproductive center of the flower (and earning the plant its common name). The velvety beard may also provide a secure landing pad as the bee seeks out nectar and, in the process, accidentally pollinates the flower.

One pale-flowered variety, *florentina*, is cultivated for its sweet-smelling rhizome, called "orris root." This is dried and used in perfumery, not just for its own fragrance but also to bind and enhance other scents. In addition, orris root is used in aromatherapy and to prolong the fragrance of potpourri. Its distilled essence is used to flavor some brands of gins. In the eighteenth century, orris root was added as a scent to the powder which men used to whiten their wigs and women applied to give their wigs a fashionable bluish-gray color.

AZTEC LILY

Sprekelia formosissima

---◆---

FAMILY: *Amaryllidaceae*
(Daffodil family)
FORM: *Herb*

HEIGHT: *16–28 in.*
NATIVE RANGE: *Mexico and*
Guatemala

The delicate, butterfly-like, crimson flowers of Aztec (or Jacobean) Lily certainly live up to the specific name *formosissima*, which means "perfectly formed" or "most beautiful." *Sprekelia* honors a lawyer from Hamburg called Johann Heinrich von Spreckelsen, a friend of the taxonomist Carl Linnaeus who first described the genus in the late eighteenth century.

As in all members of the Daffodil family, the flowers have six lobes. These are all colorful and showy, rather than being differentiated between sepals and petals, so botanists call them all "tepals." The three

upper tepals are narrow and pointed, the top one is upright, and the outer two arch downward. The three lower tepals are united at their base and rolled into a tube around the reproductive center of the flower. This is thought to give easier access to pollinating hummingbirds, which are especially attracted by red flowers. That is also a clue to the origins of this popular garden perennial: it is now thought to be native to rocky hillsides in Mexico, where hummingbirds are common, from Chihuahua in the north to the southern state of Oaxaca, and perhaps also in Guatemala.

Mexico once belonged to the Aztec kingdom, so the common name is appropriate. It then became part of the Spanish Empire, and the first Aztec Lilies reached the gardens of Europe, initially via Spain, by 1593. They were then known as *Amaryllis formosissima*, which is also the label on the featured painting. Today, they are widely cultivated from bulbs for their clumps of mid-green strap-like leaves and delicate spring flowers. In colder climates, they are mainly grown in pots on sunny windowsills, or in mixed plantings with succulents in cool greenhouses.

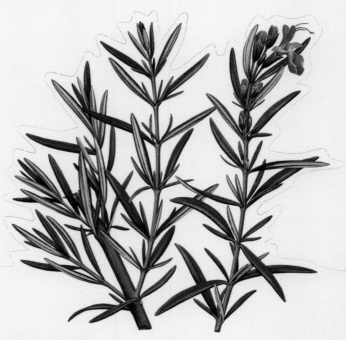

ROSEMARY

Rosmarinus officinalis

— — — ◆ — — —

FAMILY: *Lamiaceae (Mint family)* **HEIGHT:** *20–80 in.*

FORM: *Shrub* **NATIVE RANGE:** *Mediterranean*

This handsome, bushy evergreen shrub, with narrow, needle-like leaves, is native to the Mediterranean region, east to Lebanon and the Canary Isles. It is often grown in backyards for its attractive purple-blue flowers, strong scent, and culinary uses, and is a valuable nectar source for early foraging honey bees. It was first recorded in British gardens as early as 1375.

As a native plant, it belongs in the *maquis*—the mid-height, shrubby vegetation that is characteristic of dry heathland around the Mediterranean Sea. The volatile oils that produce its heady scent have a vital role in its survival there: they hang heavy in the air above the

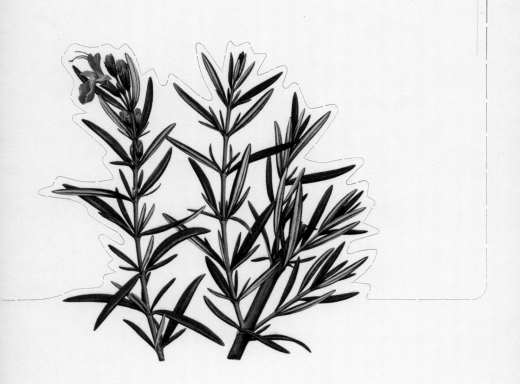

plant, saturating the air and so reducing the evaporation of precious water from the surface of its leaves.

Rosemary is commonly used as a herb in cooking, especially with lamb, fish, and potatoes. "Oil of Rosemary," extracted from the foliage, is used in perfumery, cold creams, and soaps, and is a component of *Eau de Cologne*. It has been used since Roman times to improve and strengthen the memory (and to ease headaches by improving blood flow to the brain), and it has a longstanding reputation as a tonic and invigorating herb. Medicinal research has shown that one of its constituents, *rosmaricine*, does indeed have mild analgesic properties.

Its common and scientific names are derived from the Latin for "dew" (*ros*) and "sea" (*marinus*), so it is the "dew of the sea." An alternative explanation is the myth that the Virgin Mary spread her blue cloak over a white-blossomed Rosemary bush when she was resting. Its flowers henceforth turned blue, so it is the "rose of Mary" (although this is more probably a fanciful later invention to explain the name).

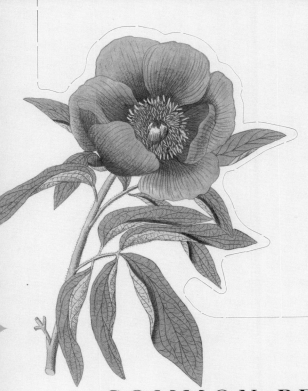

COMMON PEONY

Paeonia officinalis

❖

FAMILY: *Paeoniaceae* **HEIGHT:** *12–24 in.*

FORM: *Herb* **NATIVE RANGE:** *Southern Europe*

Any plant with *officinalis* as its specific name is likely to have an interesting story. Since the Latin term translates as "of the shop," it usually applies to species that have many traditional herbal uses.

Common Peony has been used since ancient Greek times as a treatment for epilepsy, although, if misused, it can be a deadly poison. Its common and scientific names celebrate Paeon, physician to the Greek gods. The Greek physician Dioscorides recommended peony root to encourage menstruation in women and suggested that it could be taken to expel the placenta after childbirth. These days, the related Chinese Peony (*P. lactiflora*) is more widely used in herbal medicine.

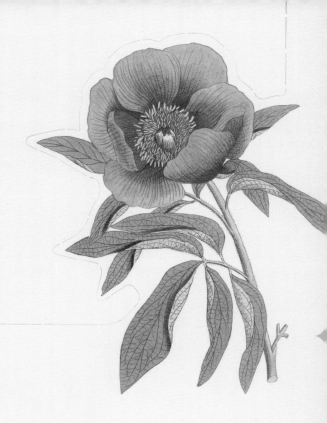

As a wild plant, Common Peony is found in mountain woods and meadows in southern Europe, from the Balkans to southern France. It is quite variable, with four different subspecies recognized across its range, based on the shape and hairiness of their leaves. In several countries it is threatened by land-use changes, including conversion of native grasslands for agriculture, increased use of pesticides, and extensive plantations of non-native trees.

This is the most common of several herbaceous and shrubby species of peony kept in backyards. It was introduced to Britain in medieval times, probably by monks because of its herbal uses, and still turns up, semi-wild, as a garden outcast, even in northern Scotland where the climate is very different from its Mediterranean home. A related widespread Mediterranean species, *Paeonia mascula*, was introduced to Steep Holm, an island in the Bristol Channel on the southwest coast of England. It has been recorded there since 1803, but probably originated several centuries earlier when there was a priory on the island.

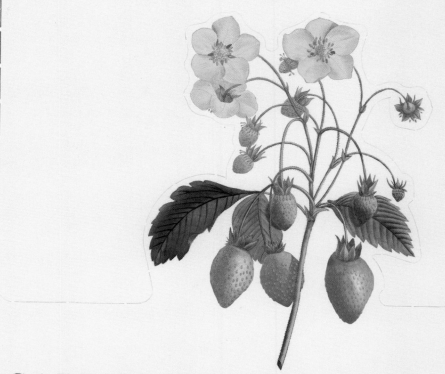

GARDEN STRAWBERRY

Fragaria x ananassa

--- ◆ ---

FAMILY: *Rosaceae (Rose family)*　　**HEIGHT:** *6–20 in.*

FORM: *Herb*　　**NATIVE RANGE:** *Cultivation only*

In upland grassland, woods, and hedgerows across Europe and North America, you can find delicate, creeping plants with silky-hairy three-lobed leaves and small white five-petaled spring flowers. These develop into swollen red fruits, not much bigger than a blackcurrant, which are beautifully sweet and flavorful. This is the Wild Strawberry *Fragaria vesca*.

The Garden Strawberry may be bigger, but it sometimes tastes as if it has the same amount of flavor spread through a much greater volume of flesh! It originated in Europe as a hybrid between two American species. Virginia Strawberry *F. virginiana*, a woodland species

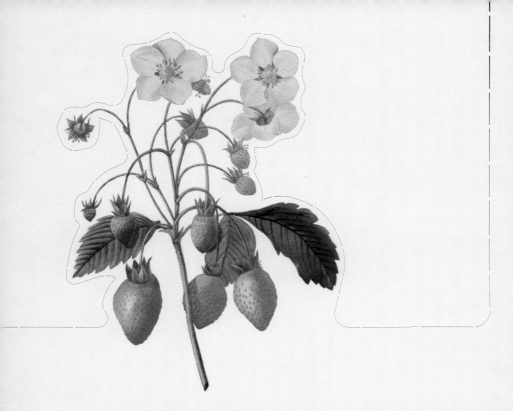

from the eastern United States, was first brought to France in 1624 by the botanist to King Louis XIII. Cultivars were developed that were good for canning and jam-making, and these soon became popular in backyards across Europe. Almost a century later, Beach Strawberry *F. chiloensis*, from the western seaboard of North and South America, was brought to Europe by a French naval officer in 1712.

When these two species from opposites sides of America were grown together in European backyards, they began to produce hybrids. These were rather larger with a pineapple-like flavor, hence their scientific name of *ananassa*, after the pineapple *Ananas comosus*. Gardeners continued to breed new cultivars with bigger and sweeter fruits, and by the beginning of the twentieth century the hybrids had displaced all the wild species in backyards.

When we eat a strawberry, we are consuming what is technically a "false fruit." The brightly colored, juicy flesh develops from the swollen base of the flower. The true fruits are actually the small yellow pips embedded in the red skin, which botanically are classed as achenes (dry, single-seeded fruits).

CLIMBING
TRIGGERPLANT

Stylidium scandens

- - - - ◆ - - - -

FAMILY: *Stylidiaceae* **HEIGHT:** *12–80 in.*
FORM: *Herb* **NATIVE RANGE:** *Southwest Australia*

It is always intriguing when plants move. Time-lapse photography shows that many do. Climbers spiral as they grow, to find support; some flowers slowly turn to follow the sun. A few plants show lightning-fast movement, and triggerplants are among those.

Most of the 140 or so species of triggerplants are found exclusively in Australia. Climbing Triggerplant grows only in sandy soils in the far southwest of the country. Its upper leaves end in hooked barbs which help it scramble over surrounding vegetation.

The flowers of triggerplants are springloaded for pollination. In the center of the flower, two stamens (male parts) are fused together onto the style (female part) to form a column. The five petals are united into a tube around the column, each with two or three small upright appendages around the tube entrance. When an insect touches one of these appendages, the trigger is released, and the column rapidly springs upward then downward onto the insect's back. The stamens dust pollen onto its back and the stigma collects any pollen it is already carrying from other flowers, to complete the process of fertilization. This is entirely harmless to the insect.

The leaves and flowers are also covered in hairs with glands that secrete a sticky mucilage (a mixture of sugar and water). An insect brushing against this can get trapped. This probably originated as a defensive mechanism to stop ground-dwelling insects from climbing into the flowers and stealing pollen. However, the glands in at least one species of triggerplant have been shown to produce digestive enzymes. These may allow the plant to dissolve the trapped insect and absorb nutrients that nourish its growth in poor soils.

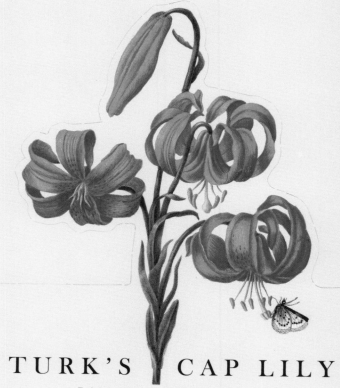

TURK'S CAP LILY
Lilium superbum

— — — ◆ — — —

FAMILY: *Liliaceae* **HEIGHT:** *35–83 in.*
FORM: *Herb* **NATIVE RANGE:** *Eastern US*

Turk's Cap Lily is the largest and most spectacular of the native lilies of North America, widely grown in backyards for its dramatic flowers. Up to 40 of these flowers have been counted on a single plant, although three to seven blooms is more typical.

The nodding flowers live up to the name *superbum*. They have six colorful "perianth parts" (flower lobes), which botanists regard as three sepals and three petals. These are deep yellow to reddish-orange in color, and curve upward from the nodding flower, often with a reddish edge to their tip. A green streak at the base of each lobe forms a six-pointed star around the central tube.

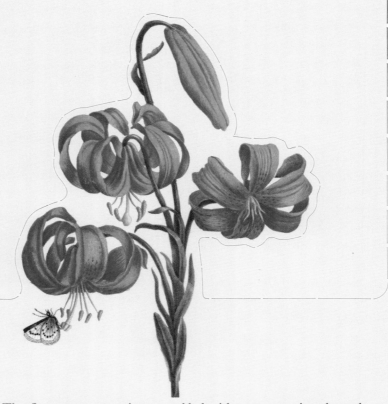

The flowers are sometimes speckled with spots, earning them the alternative name of American Tiger Lily. They produce sugar-rich nectar to attract pollinating hummingbirds and larger day-flying insects, such as sphinx moths, hummingbird moths, long-tongued bees, and larger butterflies.

The species is also known as Swamp Lily because it grows in swamps and wet meadows, from southern New Hampshire down the east coast of North America as far south as Alabama. The more widely used common name comes from the shape of the flowers: the curved-back floral lobes are said to resemble a type of cap worn by early Turks. Native Americans used the plant's white bulbs as a substitute for soap.

One curious feature of this and several other lily species is that all parts of the plants are toxic to cats, causing kidney failure. Cat owners are advised not to grow them in their gardens, or bring fresh flowers into the house, in case cats brush against them and get dusted with pollen, which the fastidious cats will then ingest as they clean themselves.

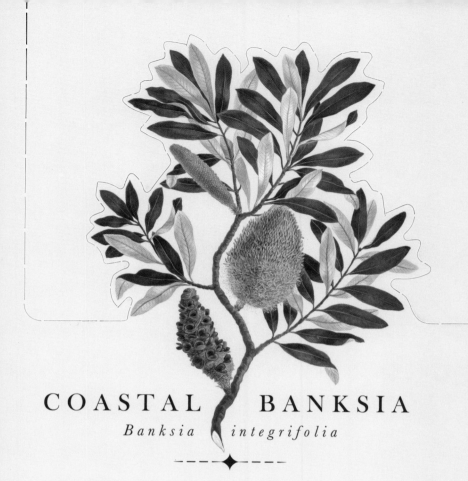

COASTAL BANKSIA
Banksia integrifolia

FAMILY: *Proteaceae (Protea family)*
FORM: *Tree*

HEIGHT: *33–50 ft.*
NATIVE RANGE: *Eastern Australia*

Banksias are as iconically Australian as koalas or kangaroos, with all 71 species entirely confined to non-arid parts of Australia. They are in the same family as the Proteas, which are equally iconic features of South Africa, and the macadamia nut of South America.

The genus is named after Joseph Banks, who was the botanist on Captain James Cook's expedition in 1768–71 on HMS *Endeavour* to explore *Terra Australis Incognita*—the land we now know as Australia. Banks was such an enthusiastic plant collector that Cook named Botany Bay in his honor. He brought back 30,000 plant specimens, including around 1,400 species new to science, several of which we would now call banksias.

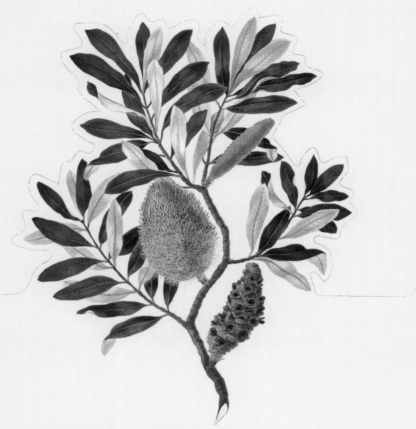

Coastal Banksia is one of the tallest and most attractive of the genus. It has dark glossy green leaves with no teeth or lobes around their edges, hence its specific name, *integrifolia*, meaning "whole leaves." Its many flowers are arranged in upright cylindrical clusters that are 2½–5 inches in length. The flowers, which open from the bottom of the spike first, are pale yellow when young and darken with age to a bronze color.

A wide range of animals visit the flowers for pollen, including many insects, and honeyeaters, wattlebirds, lorikeets, and other birds. Studies have shown that non-flying mammals, such as Squirrel Gliders and Sugar Gliders, play a critical role in pollinating the flowers, which are also visited by Gray-headed Flying Foxes (a type of bat).

The species is found around the coasts of eastern Australia, from Port Phillip Bay beside Melbourne in Victoria to northern Queensland. Although it can be a tall tree, it grows as a stunted and twisted bush when exposed to strong sea winds.

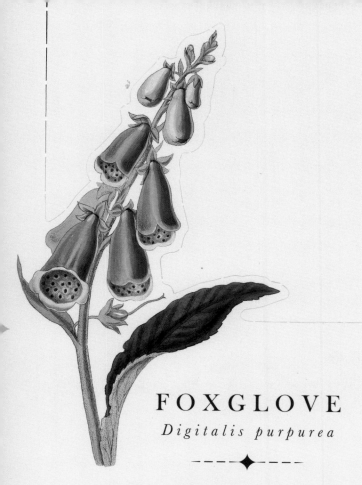

FOXGLOVE

Digitalis purpurea

--- ◆ ---

FAMILY: *Scrophulariaceae*
(Figwort family)
FORM: *Herb*

HEIGHT: *2–80 in.*
NATIVE RANGE: *Western and central Europe*

Foxglove is a traditional plant of English cottage gardens, partly because of its herbal uses (although it is highly poisonous if misused). In mythology, it was regarded as a fairy's or goblin's plant, probably from its distinctive height and the glove-shape of its flowers. The genus name *Digitalis* also comes from the Latin for fingers or thimbles. As a result, it was perceived as a powerful herbal plant, used as a treatment for vomiting, "king's evil" (a skin disease), and dropsy (the old-fashioned term for an accumulation of fluid in the body tissues).

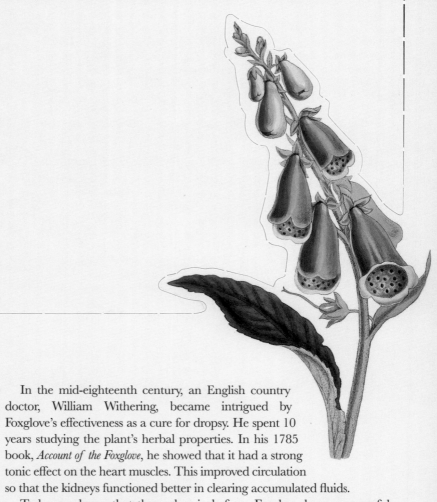

In the mid-eighteenth century, an English country doctor, William Withering, became intrigued by Foxglove's effectiveness as a cure for dropsy. He spent 10 years studying the plant's herbal properties. In his 1785 book, *Account of the Foxglove*, he showed that it had a strong tonic effect on the heart muscles. This improved circulation so that the kidneys functioned better in clearing accumulated fluids.

Today, we know that three chemicals from Foxglove have a powerful effect on the heart and circulatory system: digoxin, digitoxin, and lanatoside. These are still used in modern medicine, although digoxin is the preferred long-term medication to strengthen and regulate the heartbeat. One digoxin product is reported to be worth $50 million a year to the pharmaceutical company that markets it. None of these chemicals can be synthesized, so Foxglove is widely cultivated for medicinal use, along with its relative Woody Foxglove *Digitalis lutea*, from central Europe, which contains these active ingredients in greater quantities.

Foxglove flourishes in disturbed ground, and is quick to establish; for example, when forests are clearfelled in Europe. Unfortunately, this has allowed it to become a troublesome weed in the western United States.

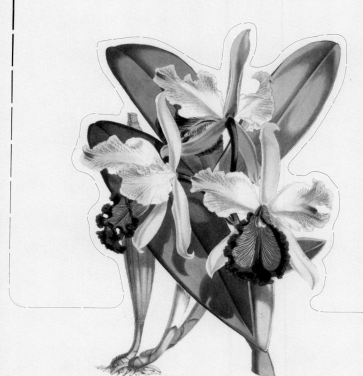

QUEEN OF THE CATTLEYAS

Cattleya dowiana

---◆---

FAMILY: *Orchidaceae* **HEIGHT:** *6–10 in.*
FORM: *Herb* **NATIVE RANGE:** *Central America*

Cattleyas are among the most exquisite of all orchids, with brightly colored, extravagant flowers. These have a large, glistening lower lip, marked with striking veins, often with a fringed tip, and produce a rich, sensual perfume. They are relatively easy to maintain in culture, and regularly feature in orchid displays in tropical hothouses around the world.

However, *Cattleya dowiana* is the queen of them all, as our artwork shows. In his 1893 book, *About Orchids*, the English botanist Frederick

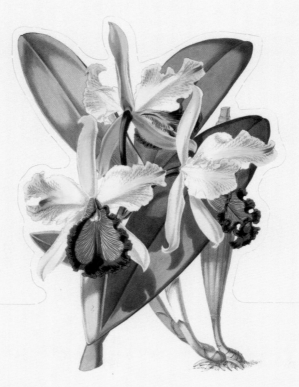

Boyle described it as "the most gorgeous, the stateliest, the most imperial of all flowers on this earth...." It is found in Panama and Costa Rica, only on the Atlantic slopes of the mountains, on mature tree crowns high above the ground, where it receives abundant light and rain. In Costa Rica, it is known as *guaria de Turrialba*; guaria may mean "sail," from the billowing petals, and Turrialba is the forest region where it is best known.

The species is difficult to propagate in cultivation, so wild plants are often collected for sale. Costa Rican law makes it illegal to collect wild cattleyas, but poaching has driven down wild populations. *Cattleya dowiana* is a parent to most of the yellow Cattleya hybrids in cultivation.

The story of the discovery of cattleya orchids is remarkable. A naturalist called William Swainson was sending ferns and mosses from Brazil to William Cattley, a plant collector in London. He packed them in miscellaneous local green plant material. Cattley planted some of this material, and by 1818 one had grown to produce spectacular purple orchid flowers. The genus was named in his honor, and the species he grew, *Cattleya labiata*, is now the national flower of Brazil.

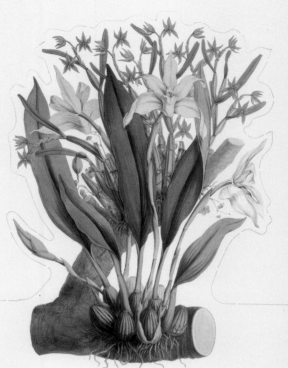

EPIPHYTIC ORCHIDS

Scaphyglottis imbricata and
Maxillaria eburnea

❖

FAMILY: *Orchidaceae*
FORM: *Herbs*

HEIGHT: *8–24 in.*
NATIVE RANGE: *Rainforests of
Venezuela*

In the rainforest, little sunlight can penetrate the dense tree canopy to the forest floor far below. The regular clouds that bring more than 100 inches of annual rainfall further reduce sunlight. Most plants need sunlight to produce their food, through photosynthesis, so few can survive on the dimly lit forest floor. Many smaller herbaceous plants have developed a trick for survival: they grow high above the ground as "epiphytes" (plants that grow on other plants) on the branches or trunks of trees. Falling dead leaves

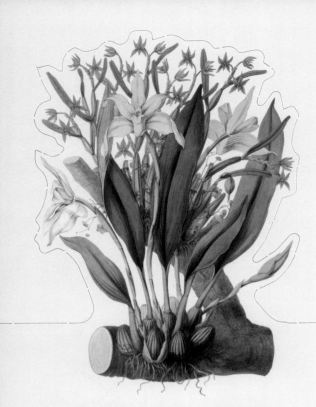

from the branches above provide the nutrients they need for growth.

This historic painting by John Lindsay of two epiphytic orchids is rather special. It first appeared in a magnificent 1838 volume called *Sertum Orchidacearum*, which notes that it was based on "drawings brought home from Guyana by Mr. Schomburgk." However, we know that the Prussian naturalist Robert Schomburgk set off by canoe from northern Brazil in September 1838 to explore the mountains of Venezuela, not Guyana. He recorded the orchids growing abundantly there on the forested slopes of Mount Maravaca, 5,250 feet above sea level.

The white-flowered orchid, named *Maxillaria eburnea* (meaning "ivory white"), has never been refound in the wild, although its home is still remote and rarely visited. Normally every scientifically named plant must be represented by one pressed specimen in a herbarium. Other plants can then be matched against this "type specimen" to confirm whether they are the same species. In the absence of a physical specimen, however, the painting reproduced here is regarded as the "type" for this elusive orchid.

The red orchid, painted as *Diothonea imbricata* but now known as *Scaphyglottis imbricata*, still occurs from Mexico to Peru.

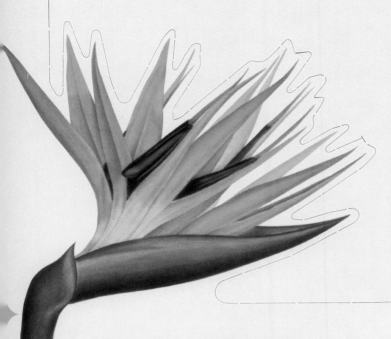

BIRD-OF-PARADISE FLOWER

Strelitzia reginae

— – – ◆ – – —

FAMILY: *Strelitziaceae* **HEIGHT:** *3–5 ft.*
FORM: *Herbs* **NATIVE RANGE:** *South Africa*

Bird-of-paradise (or Strelitzia for short) is certainly a weird flower. Botanists often struggle to work out how such flowers are related to other species, so Strelitzia is placed in its own family. This includes five species of *Strelitzia* in South Africa, the Traveler's Tree *Ravenala madagascariensis* from Madagascar, and a South American tree, *Phenakospermum guyannense*. Another related South African species, *Strelitzia nicolai*, is also a tree, known as Wild Banana—and the family probably is distantly related to bananas.

The genus is named after the wife of Britain's King George III, Queen Charlotte (1744–1818), who came from the German family of

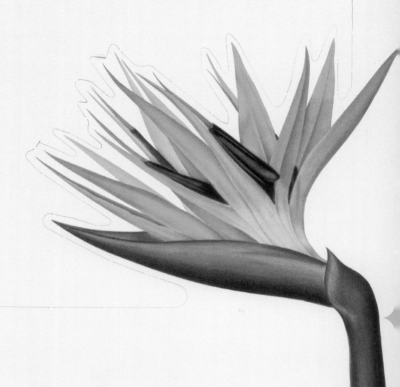

Mecklenburg-Strelitz. She was a keen amateur botanist who, through her royal patronage, helped develop Kew Gardens outside London as a major scientific collection.

Strelitzia reginae grows wild in coastal heathlands of the Eastern Cape and KwaZulu-Natal in South Africa, where it is known as Crane Flower for its beak-like inflorescence. It is widely grown in backyards, but cannot survive temperatures lower than about 50°F. It has no stem; instead its leaves and flowerstalks emerge directly from a large rhizome underground. The specific name *reginae* (meaning "queenly") celebrates its imposing flowers, which are orange with blue styles (the pollen-receptive female parts of the flower) and push their way upward, one after another, from an enclosing leathery boat-shaped floral leaf called a bract.

The flower is pollinated mainly by sunbirds. When these land on its tubular base, their weight presses open the flower tube so they can reach for sweet nectar inside. In the process, the stamens brush pollen onto the back of the bird, which then flies to another flower, where the pollen is collected by the projecting style, enabling pollination.

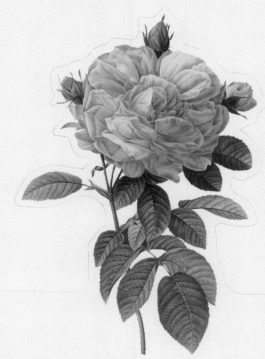

PROVENCE ROSE

Rosa gallica

- - - ◆ - - -

FAMILY: *Rosaceae*
FORM: *Shrub*
HEIGHT: *28–60 in.*
NATIVE RANGE: *Southern and central Europe*

Provence Rose is a scrambling hedgerow shrub, with prickly stems and delicate, open five-petaled flowers that are deep pink in color and sweetly scented. The flowers would grace any backyard, yet, as our artwork shows, gardeners have sought to further "gild the lily" (or rose) by creating flowers with multiple petals. The resulting frilly cultivars have the advantage of retaining their flowers for longer than natural single flowers.

Double-flowered varieties do occasionally occur naturally. The Greek philosopher Theophrastus described double roses in 286 BC,

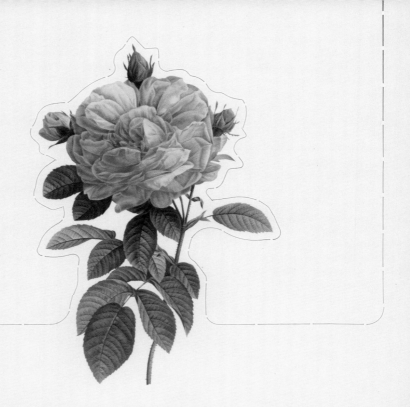

and Pliny the Elder, the Roman author, wrote about a 100-petaled rose in AD 78. Wild roses normally have five petals, inside of which are numerous pollen-producing stamens. Like all flower parts, these originated as specialized leaves, highly modified for their role in the flower.

Double flowers arise from a genetic coding error that results in some, or all, of the stamens developing into petals instead. The term "double flower" is therefore a misnomer, because it can have many more than twice the original five petals. Gardeners refer to "semi-double" roses with 9 to 16 petals, "double roses" with 17 to 25, "full flowers" with 26 to 40, and "very full flowers" with 41 or more petals.

Rosa gallica is the wild ancestor of most garden roses. It was first cultivated by the Romans, but was widely developed in France in the early nineteenth century, producing intricate multi-petaled flowers in shades of red and purple. It is thought to be the Red Rose of Lancaster, the county flower of Lancashire in the north of England. This was first adopted as a heraldic device by the Earl of Lancaster in 1267 and later became one of the badges of King Henry IV.

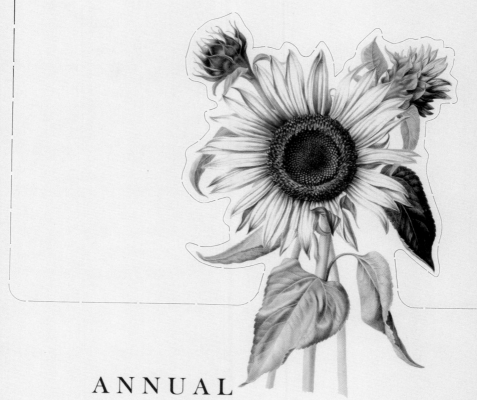

ANNUAL SUNFLOWER

Helianthus annuus

------ ◆ ------

FAMILY: *Asteraceae (Daisy family)*
FORM: *Herb*

HEIGHT: *30–120 in.*
NATIVE RANGE: *North and Central America*

Archeological evidence suggests that the natural range of Annual Sunflower was Mexico, Arizona, and New Mexico, where it was first cultivated over 4,000 years ago. Seed was ground into flour for cakes and bread. Dyes from the plant were used in textiles and for body painting. The oil was used against snakebite, and the dried stalk as a building material.

The "Hearbe of the Sunne" was first described in Europe in 1569 in a book by the Spaniard Nicolas Monardes, in which he said it had been

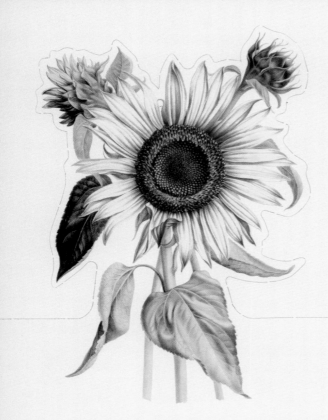

introduced into Spanish backyards a few years previously. It was quickly adopted by European gardeners, and is still widely grown for ornament in backyards throughout temperate countries.

Sunflower is also cultivated commercially for its seeds. Extracted oils are used to produce soft margarines, domestic cooking oils, and salad dressings, as well as in soapmaking, paints, and lubricants, and in bird and pet foods. In 2016–17, Ukraine was the largest producer of sunflower seeds, with a total crop of 11.9 million tons, followed by Russia, the EU (mainly France and Spain), and Argentina. China and the United States are also major producers. Plants sometimes appear in backyards, apparently spontaneously, from discarded bird seed.

The remarkable thing about this species, given the height it can reach, is that it is an annual that grows afresh from seed each year. It is sometimes claimed that its flowerheads track the sun, but this was shown to be wrong as early as 1597 by the English botanist John Gerard. Instead, flowerheads of mature plants always point in the same fixed direction (usually eastward), giving a false impression that they are following the sun.

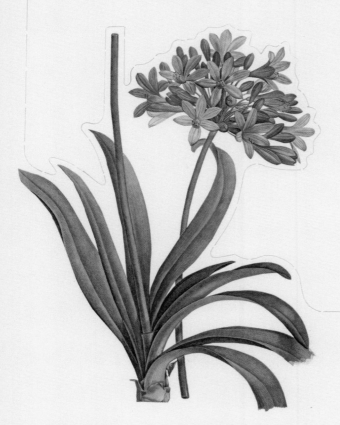

AFRICAN BLUE LILY

Agapanthus praecox

◆

FAMILY: *Agapanthaceae*　　**HEIGHT:** *16–40 in.*
FORM: *Herb*　　**NATIVE RANGE:** *South Africa*

This meticulous painting is labeled *Agapanthus umbellatus*, but these days gardeners usually refer this plant to *A. africanus*, the Cape Agapanthus, which grows wild on rocky slopes on coastal mountains in the southwestern Cape Province of South Africa. The problem is that this species is incredibly difficult to grow in backyards and is rarely cultivated. The plant commonly sold as African Blue Lily (and illustrated in our artwork) is in fact *A. praecox*, the Common Agapanthus, the tallest and showiest of the African species

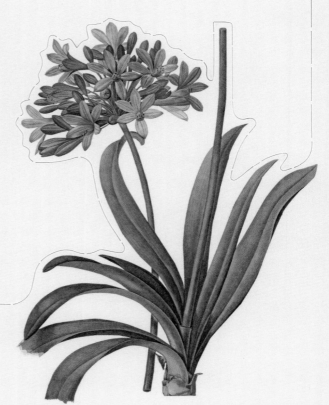

that was first exported to Europe around 1629. This is a much more widespread native plant on rocky sandstone slopes along the southeastern coast of South Africa, flowering from December to February.

By whichever scientific name, this is one of the best known of South Africa's garden plants, commonly grown in many countries. Its clumps of evergreen strap-shaped leaves and clusters of pale-blue, or sometimes white, trumpet-shaped flowers make it a favorite for sunny herbaceous borders in street plantings, large parks, and backyards. Plants have become widely established in the wild, including in Madeira, the Canary Islands, New Zealand, and Central America.

Despite its common name, the African Lily was previously regarded as a member of the Onion family, Alliaceae. However, this family characteristically contains various sulphur compounds that give members their onion or garlic smells. These compounds are absent in African lilies, which are now usually placed in their own family, with just the single genus Agapanthus and nine species in southern Africa. DNA sequencing suggests the family is probably closest to the Daffodil family, Amaryllidae.

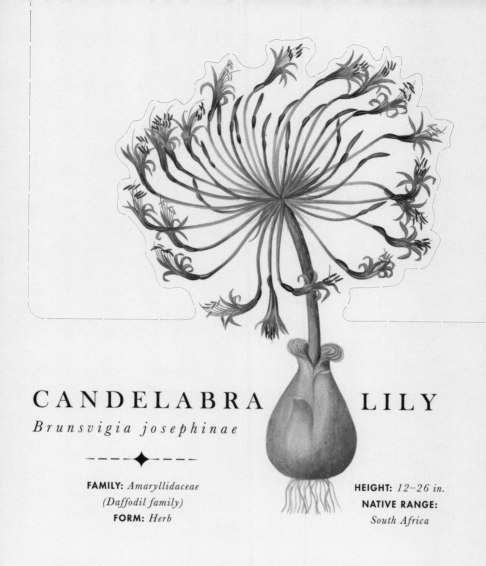

CANDELABRA LILY

Brunsvigia josephinae

◆

FAMILY: *Amaryllidaceae*
(Daffodil family)
FORM: *Herb*

HEIGHT: *12–26 in.*
NATIVE RANGE:
South Africa

Fire, usually sparked by lightning, is a natural feature in dry Mediterranean habitats not just around the Mediterranean Sea but also in other areas with a similar climate, including California and South Africa. Passing fires clear away competing vegetation and create an open, mineral-rich soil bed, in which some plant species are adapted to flourish.

After fires in the *fynbos* heathlands of the Cape Floral Kingdom in South Africa, typically a range of fire-tolerant species rapidly burst forth in the blackened ground. Some germinate from seeds after the fire has passed.

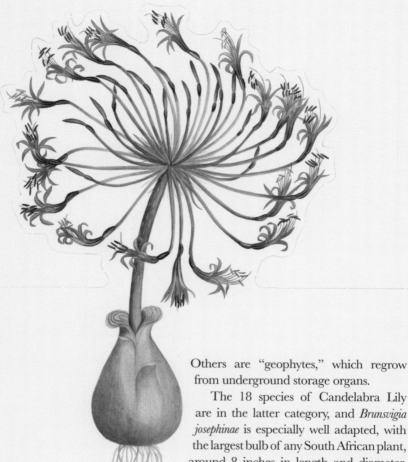

Others are "geophytes," which regrow from underground storage organs.

The 18 species of Candelabra Lily are in the latter category, and *Brunsvigia josephinae* is especially well adapted, with the largest bulb of any South African plant, around 8 inches in length and diameter. The tip of the bulb often protrudes above ground, but it seems immune to passing fires.

Shortly after the fire has gone, one bud from the bulb begins to grow into a single sturdy flowerstalk. When fully developed, this is topped by a large, widely branched flowerhead, with 20 to 50 funnel-shaped dark-red flowers. An upright cluster of leathery leaves develops after the flowers. The open, spreading inflorescence allows easy access to nectar-eating sugarbirds, which are attracted by the red color and pollinate the flowers. Then the flowers wither. The hemispherical flowerhead breaks off and rolls as a tumbleweed in the wind, scattering its seeds into the fertile seedbed left by the fire.

The species is said to be named after Josephine, the mistress and empress of the French Emperor Napoleon.

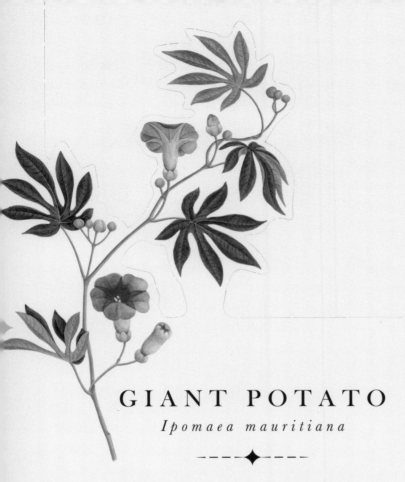

GIANT POTATO

Ipomaea mauritiana

◆

FAMILY: *Convolvulaceae*
(Bindweed family)
FORM: *Shrub*

HEIGHT: *10–33 ft.*
NATIVE RANGE: *Southeast Asia*

Giant Potato is one of around 650 species of climbing vine plants in the genus *Ipomoea*. They are commonly known as "morning glories" for their flowers, which typically last for just a single day or night. The genus also includes the Sweet Potato, *Ipomoea batatas*, which is cultivated and eaten in the tropics, and used as a source of sugar and industrial alcohol.

The name Giant Potato is confusing—it relates to its large tubers (underground stems), but these are not edible, and neither the Giant nor Sweet Potato belong to the true potato family, Solanaceae. However, extracts from the tuber do have medicinal uses, for example in the treatment of

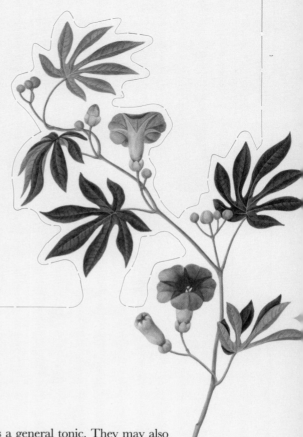

fevers and bronchitis, or as a general tonic. They may also have aphrodisiac properties and are reported to be used in Bangladesh for the treatment of "sexual disabilities."

Giant Potato is probably native to montane forests and disturbed ground in Southeast Asia, Sri Lanka, Mauritius (hence its specific name), New Guinea, the Philippines, Pacific Islands, and Northern Territory of Australia, but humans have now distributed it widely throughout the tropics.

It is sometimes grown in gardens for its delicate five- to seven-lobed leaves and its handsome funnel-shaped flowers. These are pink to reddish-purple in color, with darker throats, and up to 2 inches in diameter. In warm backyards, it will grow as an annual (completing its entire lifecycle within a year) but, even in that time, with a fence for support, its scrambling stems can reach a length of 10 feet. Another common name from Singapore, Railway Creeper, hints at how it can invade human-made habitats.

The genus name *Ipomoea* translates from the Greek as "like a woodworm" from the species' twining growth.

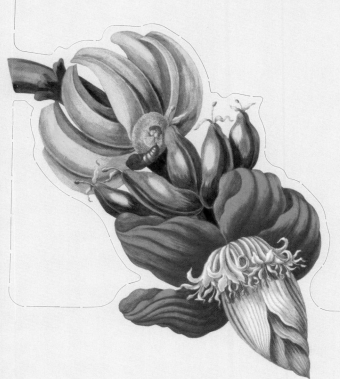

BANANA

Musa cultivar

◆

FAMILY: *Musaceae* **HEIGHT:** *7–30 ft.*
FORM: *Herb* **NATIVE RANGE:** *Southeast Asia*

Bananas are remarkable plants, second only to citrus fruits in the scale of international trade. They stand up to 30 feet tall, but they are the world's largest herbs, meaning they lack woody stems. What looks like a trunk is actually a "pseudostem," made up of the overlapping bases of the leaves. The true stem is a single swollen underground mass called a corm. Each pseudostem only flowers once, producing a single cluster of bananas. It is then felled, and the next pseudostem grows afresh from the corm.

Bananas originated by hybridization from two wild species found in Southeast Asia, but they are infertile, which is why the bananas we eat

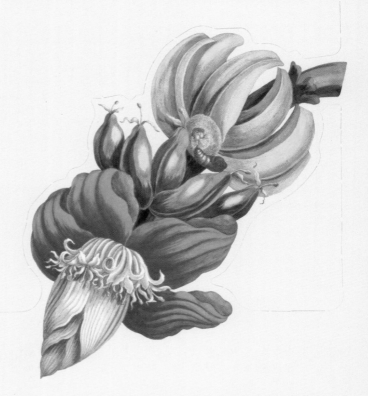

contain no seeds. The corms are longlived, and some banana patches can be 50 to 60 years old, but new plantations can only be developed by planting segments of corm that bear buds.

The pseudostems are weak and arch over as they grow. At the tip, they develop a cluster of sterile male flowers, surrounded by four large red floral leaves, called bracts, which usually drop before the bananas are ripe. Groups of female flowers further up the stem give rise to the banana fruits without any need for fertilization. Each fruit cluster consists of up to five "hands," each with five to 20 bananas. Varieties with greener, starchier fruits are grown for cooking, but there is no clearcut botanical distinction between these plantains and sweet dessert bananas.

Banana is an enormously important export crop in tropical countries, worth nearly $12.5 billion per year worldwide, but their cultivation is not without controversy. In the past, large transnational corporations had a terrible reputation for exploiting local populations, and aerial spraying of pesticides has had devastating health impacts on plantation workers.

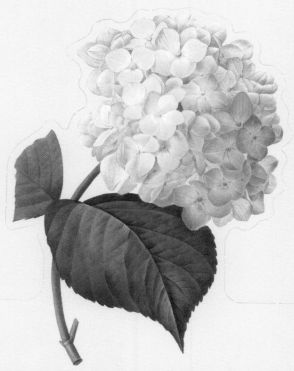

FRENCH HYDRANGEA

Hydrangea macrophylla

- - - ◆ - - -

FAMILY: *Hydrangeaceae* **HEIGHT:** *3–10 ft.*
FORM: *Shrub* **NATIVE RANGE:** *Japan and Korea*

This dome-shaped shrub is often grown in backyards, but native to Asia. Plants were first brought to European backyards by at least 1789, but, by then, Japanese horticulturalists had already developed fancy varieties and hybrids.

The original native plant probably looked like modern varieties that gardeners call "lacecap" hydrangeas. These have large flat-topped flowerheads, with a rather unusual arrangement. The outer clusters of flowers are showy and up to 2 inches in diameter. However, these consist only of four or five colorful sepals, with no other flower parts, so they are sterile. The fully functional flowers, with all their floral

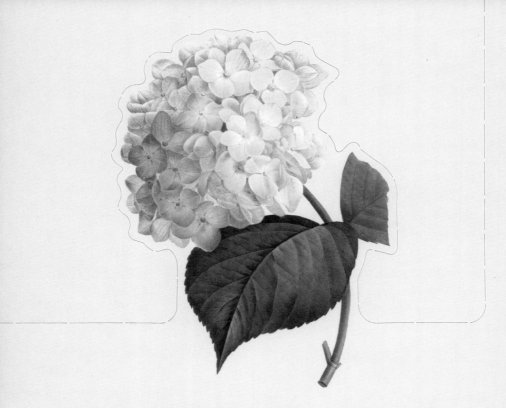

parts, are reduced to tiny florets, an eighth of an inch across, clustered in the center of the flowerhead. In effect, the sterile, outer flowers are "calling cards" which attract pollinating insects towards the central, reproductive florets. This division of labor may save energy, rather than all the flowers serving both functions.

Gardeners have taken this a stage further, breeding what they call "mophead" varieties, as shown in our painting, with spherical flowerheads consisting entirely of showy sterile flowers. As these cannot produce seeds, gardeners need to propagate them from their roots (although some "mophead" varieties do produce a few fertile flowers, with a ring of tiny petals in the middle of the showy sepals). Normally, flowers wither after pollination, but the sterile flowers can never be pollinated and so remain showy for much longer.

French Hydrangea normally has pink flowers, colored by a chemical called anthocyanin. However, if grown in acid soils, some varieties produce blue flowers. This is because aluminum ions, which are soluble only in acidic soils, are absorbed by the roots and transported to the sepals, where they turn the anthocyanin blue.

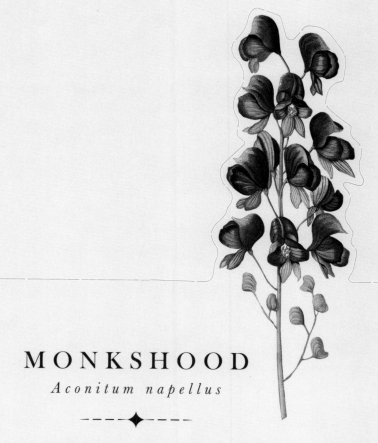

MONKSHOOD

Aconitum napellus

❖

FAMILY: *Ranunculaceae*
(Buttercup family)
FORM: *Herb*

HEIGHT: *4–80 in.*
NATIVE RANGE: *Europe and Asia*

Yards often contain a surprising number of beguiling poisons. It is no coincidence that the artwork of this handsome species comes from an early-nineteenth-century book about poisonous plants, because Monkshood (or Monk's-hood) is one of the deadliest of backyard perennials. Unfortunate people who mistake the underground tubers for Jerusalem artichoke, or the leaves for parsley, are likely to quickly experience a slowing of the pulse, soon followed by vomiting, diarrhea, and convulsions. If untreated, death from respiratory or heart failure can follow within eight hours.

The plant contains a variety of poisonous alkaloids, including aconitine. Cleopatra allegedly used this to poison her brother, Ptolemy XIV, to ensure that her son could ascend the throne. Aconitine does have modern medicinal uses, mostly as a liniment applied externally against nerve pain.

The species is quite variable in leaf shape across its range in Europe and Asia, as far east as the Himalayas. One variety, previously called *Aconitum anglicum*, appears to be endemic to shady streamsides in southwest England and Wales. However, it was first recorded there in 1799 and may be an introduction, perhaps by medieval monks.

Although the Buttercup family is sometimes regarded as one of the most primitive flowering plant families, the flowers of Monkshood are remarkably complex. Botanists say that the purple floral parts are actually showy sepals, the topmost of which forms a helmet-shaped hood. The petals are reduced to swollen nectaries. Two of these are large and tucked under the helmet, while the others are small or absent altogether. Only long-tongued species of bumblebee can reach the sweet reward of the nectaries, and are then most likely to visit other Monkshood flowers and complete pollination.

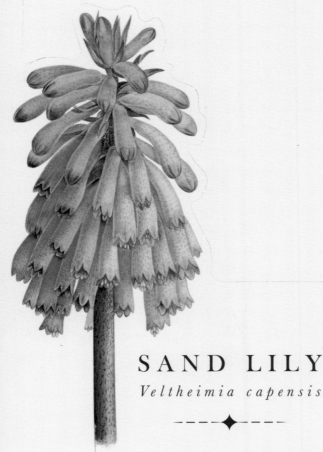

SAND LILY

Veltheimia capensis

◆

FAMILY: *Hyacinthaceae*
(Hyacinth family)
FORM: *Herb*

HEIGHT: *8–16 in.*
NATIVE RANGE: *South Africa*

Sand Lily (or *sandlelie* in the local Cape dialect) is found near coasts throughout the Cape Town area and takes readily to cultivation, although it is frost-sensitive, so best kept in a greenhouse in cooler climes. It has attractive crinkly-edged bluish-green leaves, accompanied by dense spikes of nodding tubular flowers, a little reminiscent of red-hot pokers *Kniphofia* spp., although these belong to a different family, the Aloes. Its pinkish or dull-red flowers are visited by sunbirds, which can hover beneath the inflorescence and reach with their bills into the depths of the floral tube in search of nectar.

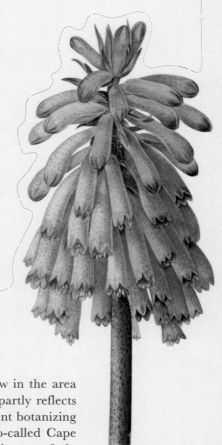

Several species in this book grow in the area around Cape Town. Perhaps that partly reflects the happy times the author has spent botanizing there, but it is also because the so-called Cape Floral Kingdom of South Africa is one of the world's richest biodiversity hotspots. It stretches from Namaqualand, adjoining Namibia in the northwest, as far east as Port Elizabeth on the south coast. It has an area of around 35,000 square miles, more or less the size of Portugal, yet it is home to 8,600 or so species of flowering plant, of which 5,800 are endemic (found there and nowhere else in the world). That total is about a third of the flowering plant species in all of Africa.

The climate there is relatively mild throughout the year, although colder in the mountains. Rainfall is mostly steady, with occasional droughts. Many of the species grow from bulbs, which allows them to regrow after dry spells, and many have showy flowers to attract pollinating insects, birds, or even bats. All of that makes them good candidates for garden propagation.

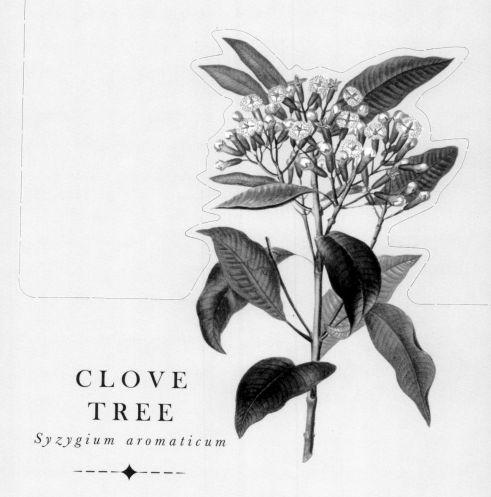

CLOVE
TREE

Syzygium aromaticum

---◆---

FAMILY: *Myrtacaceae (Myrtle family)* **HEIGHT:** *27–40 ft.*
FORM: *Tree* **NATIVE RANGE:** *Molucca Islands*

Slightly unusually, the spice we call clove is prepared from the dried, unopened flower buds of this tall evergreen tree that originated in the Maluku Islands (or Moluccas) in the Banda Sea of Indonesia, to the west of New Guinea. The islands were known as the Spice Islands because, in addition to cloves, nutmeg and mace also originated there. Arab merchants began visiting the islands from the fourteenth century onward to trade in spices. Cloves were taken to China and India in early times, and by the Middle Ages were widely used throughout Europe. They were especially

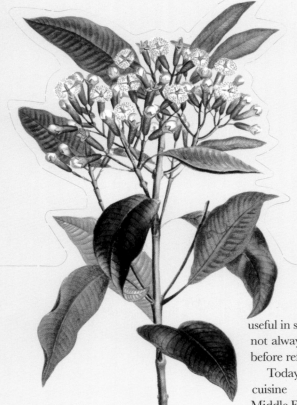

useful in seasoning meats, which were not always the freshest in those days before refrigerators.

Today, cloves are used in the cuisine of Asian, African, and Middle Eastern countries as flavoring for meat dishes, curries, marinades, sauces and pickles, and when cooking apples, pears, or rhubarb. They are used to spice up hot beverages, including mulled wine, a popular drink in Europe at Christmas time, and also play an important role in Mexican and Peruvian cooking. Oils extracted from cloves (mainly eugenol) are used in dentistry and perfumery.

The developing flowerbuds have a tubular shape, about 1 inch long, formed by the united sepals, with the unopened petals in a tight ball at the tip. The buds start pale green, become progressively darker green, then begin to develop the red color shown in our painting, at which time they are ready for picking. Trees cannot be harvested until they are four years old, but cloves can then be picked twice a year and left to dry in the sun.

The main commercial producers of cloves are Indonesia, Madagascar, the Tanzanian island of Zanzibar, Sri Lanka, Kenya, and China.

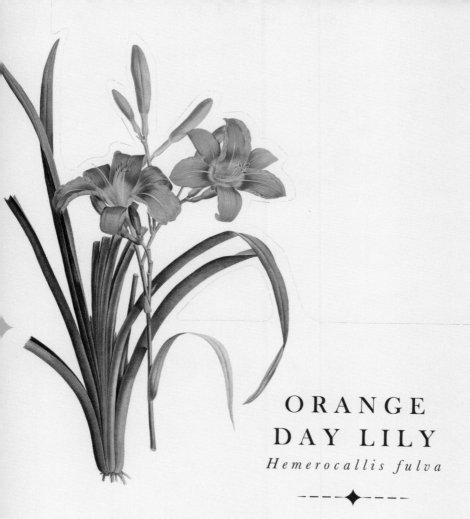

ORANGE
DAY LILY
Hemerocallis fulva

- - - ◆ - - -

FAMILY: *Hemerocallidaceae* **HEIGHT:** *24–48 in.*
FORM: *Herb* **NATIVE RANGE:** *China*

Orange (or Tawny) Day-lily is so called because its individual flowers, which are about 5 inches in diameter, scentless, and dull-orange in color, only last a single day. This is reflected also in its scientific name: *hemera* in Greek means "day" and *kallos* means "beauty." Originally classed in the Lily family, it is now generally placed in its own family.

The species probably originated in China, but it is found much more widely, from the Caucasus mountains and southeast Russia to Japan and Korea, perhaps as a backyard escape over most of this range. It is regarded

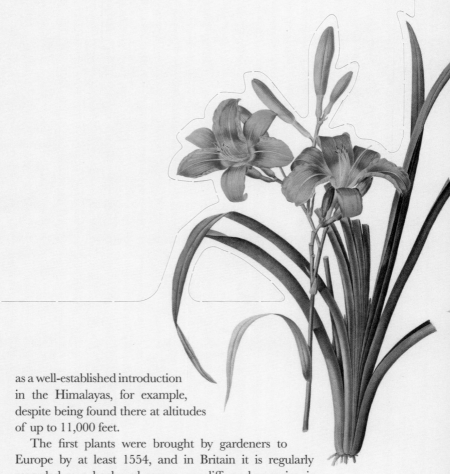

as a well-established introduction
in the Himalayas, for example,
despite being found there at altitudes
of up to 11,000 feet.

The first plants were brought by gardeners to
Europe by at least 1554, and in Britain it is regularly
recorded as a backyard escape on cliffs and quarries, in
sand-dunes and grassland. From Europe, it was taken to the United States.
The hot, humid summers of the southern states suit the species, and it has
spread from backyards to roadsides, waste ground, and ditches, earning it
the local name of "ditch lily." The species seems to be sterile, so it cannot set
seed, suggesting that it may have originated from hybridization. However, it
spreads vigorously from tuberous roots and rhizomes to form dense patches
that often squeeze out native plants and, as a result, Day-lily is classed as an
invasive weed in some parts of the United States.

This is not entirely bad news. All parts of the plant are edible. Its
orange sepals and petals taste like lettuce and make a colorful addition to
salads, and its buds are said to resemble green beans when cooked and
served with butter.

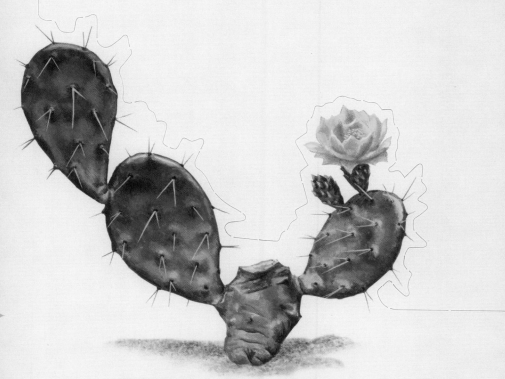

PRICKLY PEAR

Opuntia ficus-indica

────◆────

FAMILY: *Cactaceae*　　**HEIGHT:** *10–16 ft.*
FORM: *Shrub*　　**NATIVE RANGE:** *Mexico*

True cacti are native only to warmer parts of the Americas. Similar-looking plants in Africa are unrelated to cacti, but have evolved matching adaptations to cope with the same dry desert conditions.

Prickly Pear is a cactus from Mexico that has been introduced as a commercial crop in arid regions around the world, including the Mediterranean, parts of Africa, Madagascar, Australia, and the Caribbean. It is grown partly for its edible fruit, which is a valuable food in drought-prone areas, used to make jams and jellies. It is also a useful fodder crop for domesticated animals in these regions, and is planted to form impenetrable boundary hedges.

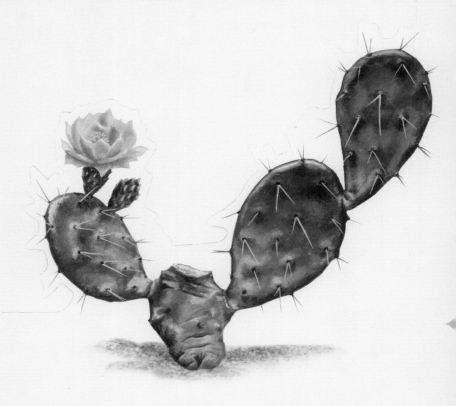

Since the fifteenth century in Central America, it has produced another valuable crop. A type of scale insect, often wrongly called a cochineal beetle, penetrates pads of the cactus with its beak-like mouthparts. It looks almost like a bird dropping as it hangs there motionless, feeding on the cactus sap. To deter predators in this vulnerable position, it produces an unpleasant-tasting fluid called carminic acid.

Farmers encourage infestations of the insects. Then they brush them off the cactus, and extract the acid from their dried bodies and eggs. The acid is mixed with aluminum to produce a bright red dye called carmine or cochineal. Before artificial dyes were available, this was highly valued for coloring fabrics. It is still used as a colorant in food and lipstick.

The insects were introduced around the world, along with Prickly Pears, as part of the commercial crop. They were taken to Australia, for example, in 1788 in the hope of starting a cochineal-dye industry there. In many countries, the plant has become an invasive weed, choking the landscape with its dense thickets.

RED BOTTLEBRUSH

Callistemon citrinus

—— ◆ ——

FAMILY: *Myrtacaceae (Myrtle family)*　　**HEIGHT:** *6½–20 ft.*
FORM: *Shrub*　　**NATIVE RANGE:** *Eastern Australia*

There are around 30 species of bottlebrushes, all with cylindrical, clustered flowerheads. They grow wild only in Australia, although they are much cultivated in backyards with hot, dry summers and mild winters for their delicate evergreen foliage and colorful flowers.

As a wild plant, Red Bottlebrush grows mainly near streams and swamps in Queensland, New South Wales, and Victoria, and is the commonest bottlebrush in the area around Sydney. It is a shrub or small tree, with spear-shaped leaves. When these are crushed, glands on their surface exude a sweet fragrance, reminiscent of citrus fruits (hence its Latin name).

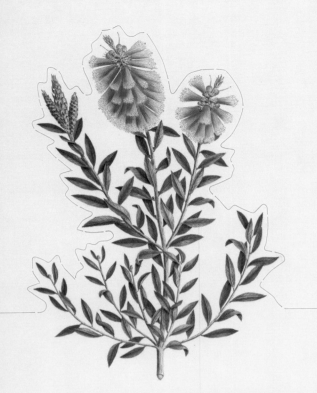

Its scarlet flowers appear in springtime, beneath a tuft of leaves at the tip of the stem that will form the new summer's growth. They are clustered into a dense cylindrical flowerhead, 2½–4 inches in length. The petals and sepals are short and inconspicuous. What you notice instead are the bristle-like, pollen-producing stamens, which are much longer than the petals and give the inflorescence the characteristic appearance of a bottlebrush. These also explain the genus name *Callistemon*, which translates from Greek as "beautiful stamens."

A variety of birds visit the flowers in search of nectar, including lorikeets, honeyeaters, wattlebirds, and silvereyes, although bees are probably its main pollinators. Crimson Rosellas (small parrots) eat its seeds.

Red Bottlebrush was one of the earliest Australian plants to be taken into cultivation. Joseph Banks, the botanist on the first of Captain Cook's famous voyages of exploration, took roots of it back to England in 1770. By 1794, plants were well established in the world-famous Kew Gardens, and were available commercially from nurseries. Its flowers often feature in floral arrangements, and, in Australia, its wood is used for making tool handles or as firewood.

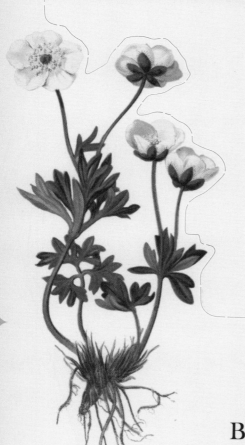

GLACIAL BUTTERCUP

Ranunculus glacialis

- - - ◆ - - -

FAMILY: *Ranunculaceae*　　**HEIGHT:** *1½–10 in.*

FORM: *Herb*　　**NATIVE RANGE:** *Europe and Greenland*

The common and scientific names of Glacial Buttercup both reflect its close association with glaciers in the mountains and high Arctic of Europe. Glacial ice moves steadily downhill, lubricated by meltwater beneath, but fresh snow is continually compacted to form further ice on top. As a result, glaciers expand and contract with varying summer temperatures and winter snowfall. This movement grinds up the underlying rock, and dumps piles of gravel along the edges and at the foot of glaciers.

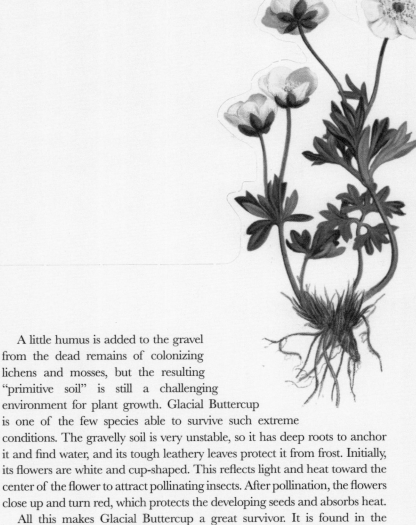

A little humus is added to the gravel from the dead remains of colonizing lichens and mosses, but the resulting "primitive soil" is still a challenging environment for plant growth. Glacial Buttercup is one of the few species able to survive such extreme conditions. The gravelly soil is very unstable, so it has deep roots to anchor it and find water, and its tough leathery leaves protect it from frost. Initially, its flowers are white and cup-shaped. This reflects light and heat toward the center of the flower to attract pollinating insects. After pollination, the flowers close up and turn red, which protects the developing seeds and absorbs heat.

All this makes Glacial Buttercup a great survivor. It is found in the Arctic, north to Svalbard in Norway and the east coast of Greenland, with a separate subspecies in Siberia and Alaska. It is the highest recorded flowering plant in Scandinavia, reaching altitudes of nearly 7,800 feet on Norway's tallest mountain, Galdhøpiggen, and has been found 15,500 feet up in the Bavarian Alps. Elsewhere in Europe, its fossilized remains can be identified in glacial soils left from the last Ice Age. Its arctic adaptations make it challenging to grow in temperate backyards, requiring constant irrigation and aeration of its roots.

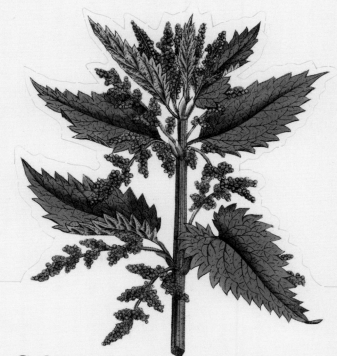

COMMON NETTLE

Urtica dioica

- - - ◆ - - -

FAMILY: *Urticaceae*
FORM: *Herb*
HEIGHT: *12–60 in.*
NATIVE RANGE: *Europe, Asia, and North America*

Common Nettle flourishes in disturbed soil with a high nitrogen content. Our activities in farms and backyards create exactly these conditions, so archeologists regard nettle patches as a possible indicator of abandoned human habitation.

Nettles are easily spread by seeds and root fragments. As a result, human activities have transported them around the world, making it unclear where they are truly native. Common Nettle probably hails originally from northern Europe and Asia, but it is remarkably climate-tolerant, allowing it

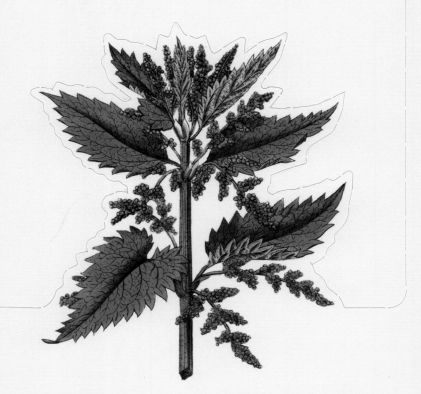

to invade warmer regions, including South America and South Africa. In Australia and New Zealand, it has become a troublesome, invasive weed. Plants in Canada and the United States are a separate subspecies with narrower leaves, although the European subspecies has been introduced there also.

Common Nettles are also known as stinging nettles (*Urtica* comes from the Latin *uro*, meaning "I burn"). The stinging hairs which cover the leaves and stems have a swollen base containing the irritant fluid, and a projecting tube with a brittle constriction near its tip. When we brush against the leaves, the tube breaks at this weak point and penetrates the skin, injecting its poison like a hypodermic needle. It may indeed be best to "grasp the nettle," because rough handling breaks the tube at a lower point so it cannot penetrate the skin.

The roots and stems of nettle are tough and fibrous. Long fibers were once extracted from these to make clothing, a practice revived during World War I. Young nettle leaves can be eaten like spinach and make excellent soups and quiches. They are valuable food plants for the caterpillars of several butterfly species. Less positively, nettle pollen is a major contributor to hayfever.

PURPLE SAXIFRAGE

Saxifraga oppositifolia

◆

FAMILY: *Saxifragaceae*
FORM: *Herb*

HEIGHT: *½–2 in.*
NATIVE RANGE: *Europe, Asia, and North America*

Purple Saxifrage is a beautiful feature in many backyard rockeries, forming a low-growing, open cushion of creeping red stems with small blue-green leaves, and producing tufts of five-petaled flowers on short stalks. Rather perversely, gardeners often seem to prefer white-flowered variants, rather than the jewel-like purple flowers that are such a startling feature of the plant in the wild.

This belies the fact that Purple Saxifrage is an incredibly tough survivor in harsh terrains across the Arctic regions of Europe, Asia, and America. It is one of an elite group of plants that survive in the

most northerly plant community in the world at 83° North in Peary Land, the northern tip of Greenland. It also grows in mountains in these continents, south to the Rocky Mountains in America. In the Alps, it reaches its highest altitude at 14,780 feet beneath the peak of the Swiss mountain called Dom.

Even more remarkably, in these harsh environments, Purple Saxifrage flowers just as the snow is melting—as early as the middle of March in the mountains of Scotland, for example, although there are few butterflies around then to pollinate it. Studies have shown that it can flower within five to eight days of emerging from beneath a blanket of snow. During the summer, its roots accumulate carbohydrates, which it stores as energy for an early burst of growth as the snow melts. Its cushions of leaves hug low to the ground, protecting it from the wind and maximizing heat from the early-spring sun.

These adaptations come at a cost. Investing so much energy in survival leaves it as a weak competitor, so it will not survive long in a rockery unless it is regularly weeded.

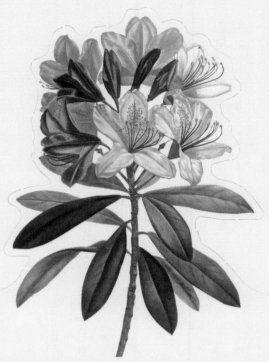

(SOUTHERN) RHODODENDRON

Rhododendron ponticum

---◆---

FAMILY: *Ericaceae (Heather family)*
FORM: *Shrub*
HEIGHT: *3–27 ft.*
NATIVE RANGE: *Southern Europe*

Rhododendrons are beautiful trees and shrubs, much sought after by gardeners. There are around 1,000 species, mainly in the Himalayas, China, and Papua New Guinea. Most have evergreen leaves and pink, funnel-shaped flowers, hence the name *Rhododendron*, meaning "red fingers."

In 1763, *Rhododendron ponticum* was introduced to Britain, probably from the Iberian peninsula although it also grows wild in Turkey and its neighboring countries. It did well, but horticulturalists soon crossed it with other species to produce what they called "hardy hybrids" or "ironclads"

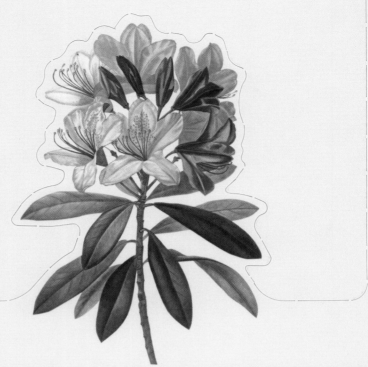

from their tough rootstocks. In stately gardens, delicate species of rhododendron were often grafted onto these rootstocks. If the gardens were abandoned, the rootstocks quickly took over and the exotics were lost.

The plant was first recorded growing wild in Britain in 1894, and seemed to grow more vigorously than in its native Spain. Grazing animals avoid the poisonous leaves, so the plants soon spread as an invasive purple swarm into moorland and farmland around stately gardens. A single plant, with its rooting branches, can spread to form a tangled, impenetrable thicket covering 1,100 square feet, beneath which nothing else can live. A bush that size can produce a million seeds a year, so its seedlings quickly blanket surrounding land.

The form that is spreading most aggressively in Britain, choking and smothering native woodlands and heathlands, is now thought to be a repeated hybrid of multiple species, given the appropriate name *R. x superponticum*. It is time-consuming and expensive to control. Felled stems must be painted or injected with herbicide to stop them regrowing, and seedlings must be regularly uprooted. It cost almost £10 million to eradicate it from just one region in 2008. The species is also established in New Zealand.

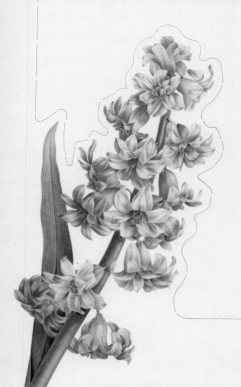

COMMON HYACINTH

Hyacinthus orientalis

◆

FAMILY: *Hyacinthaceae* **HEIGHT:** *12–20 in.*
FORM: *Herb* **NATIVE RANGE:** *Turkey to Syria*

Common Hyacinth grows naturally among rocks and low scrub in central and southern Turkey, Lebanon, and parts of Syria. It was cultivated since early times by the Turks, and bulbs were brought from there to European backyards in the late sixteenth century. Now widely grown in temperate regions for its spring flowers, it can persist for a long time in abandoned backyards or when bulbs are dug up and discarded in the countryside.

Once placed in the Lily family, it has tufts of bright-green strap-shaped leaves, from the middle of which emerges a single hollow flowering stem. This is topped by a dense cylindrical cluster of delicate

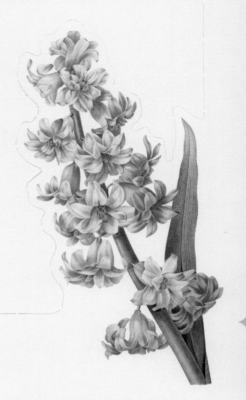

blue flowers with six, more or less equally-sized, petal-like perianth segments. In spring, these give off a sweet, heavy, almost musky smell, typical of flowers that are pollinated by moths.

Their long history of cultivation has allowed gardeners to develop over two thousand cultivars, most of which have larger and denser heads of bright blue, red, pink, or white flowers. These can often be found growing as if they were wild around the Mediterranean region. Potted hyacinths can be "forced" in cultivation, inducing them to flower earlier than their natural season, particularly in time for Christmas.

The name comes from Greek mythology. Hyakinthos was a young man whose great beauty attracted the god Apollo. Zephyrus, the god of the west wind, was jealous and fatally threw a discus at Hyakinthos's head during a competition. A flower sprang from the youth's blood, although historians argue whether the myth refers to a hyacinth, a gladiolus, or a fritillary. Some sources suggest that the Common Hyacinth might also be the "lily of the valley" referred to in the Bible.

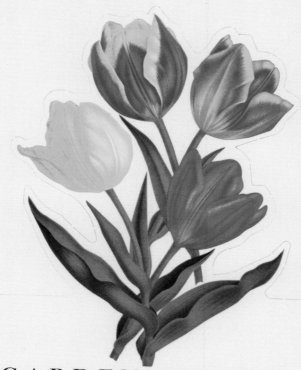

GARDEN TULIP

Tulip gesneriana

◆

FAMILY: *Liliaceae (Lily family)*　　**HEIGHT:** *12–24 in.*
FORM: *Herb*　　**NATIVE RANGE:** *Southern Asia?*

In Cyprus and elsewhere in the eastern Mediterranean, miniature tulips grow in stony ground. Sometimes they emerge from tiny soil pockets in rock crevices, like rubies embedded in stone. Their flowers are deep red with a dark-purple center, but they are surprisingly inconspicuous because the plants stand no taller than a crocus. They are very different from the tall, showy tulips we know from our backyards, like those in this artwork.

There are around 90 species of tulip in Central Asia and North Africa, and another 10 or so in southern and central Europe, although

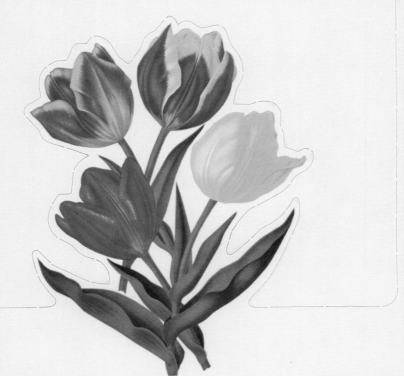

this is confused by garden forms that have become established in the wild in several countries. The majority of tulip cultivars in the garden derive from a complex species called *Tulipa gesneriana*. This may have been brought from Turkey around 1562 by Ogier Ghiselin de Busbecq, an ambassador of the Holy Roman Empire, who traveled widely in that country. No plants corresponding to this species have since been found in the wild, although somewhat similar plants grow in southern Asia.

The Garden Tulip quickly established its popularity in European backyards, and this led to a huge upsurge in imports from Asia from the sixteenth century onward. Because they grow from bulbs, tulips were easy to transport. Their leaves and flowers died soon after flowering, and the bulbs remained dormant until they were planted the following season. Numerous color variants were selected and reselected by gardeners, to produce progressively bigger and showier flowers. Their cultivation reached mania status in Holland in the seventeenth century (see page 6), and still today the Netherlands is the world's largest tulip producer, growing as many as three billion bulbs annually, mostly for export.

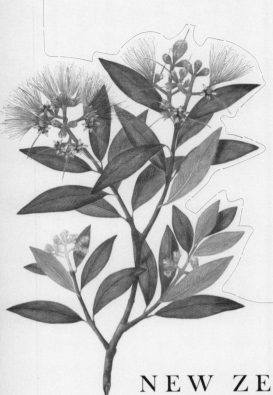

NEW ZEALAND
CHRISTMAS TREE

Metrosideros excelsa

❖

FAMILY: *Myrtacaceae (Myrtle family)*　　**HEIGHT:** *Up to 82 ft.*
FORM: *Tree*　　**NATIVE RANGE:** *New Zealand*

New Zealand split from other continents 80 million years ago, but soon sank beneath the waves and did not emerge again as a landmass until around five million years ago. Since then its plants have lived in relative isolation, and, as a result, 80 percent of the country's native flora is endemic —meaning it is found in New Zealand and nowhere else (although humans have brought in many more species, both accidentally and deliberately).

There are 260 species of trees native to New Zealand, including 11 endemic kinds of *Metrosideros*. Elsewhere, the genus is widespread in

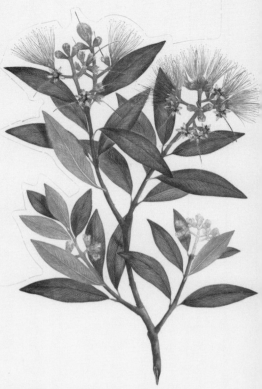

Australasia, with one species in the Cape region of South Africa and one in Hawaii. That suggests it must have very ancient origins, when all these continents were united.

Probably the best-known and most loved of New Zealand's native trees is the one in our illustration, known to the Māori as *pōhutukawa*. Perhaps it is easier to remember as the New Zealand Christmas Tree, so called because its glorious crimson blossoms are at their best in mid-December.

It is native around northern coasts of the North Island of New Zealand, but it is so widely planted around coastal regions elsewhere on both North and South Islands that it often looks native there also. Its blossoms are rich in nectar, much appreciated by honeybees and by native birds like the Bellbird and the Tui (or Parson Bird), but its main pollinator may be geckos—species of native lizards that visit the flowers in the evenings to feed on nectar.

Its wood is very strong and was used by Māori people in boat-building. The generic name *Metrosideros* refers to this strength, meaning "heartwood of iron" in Greek.

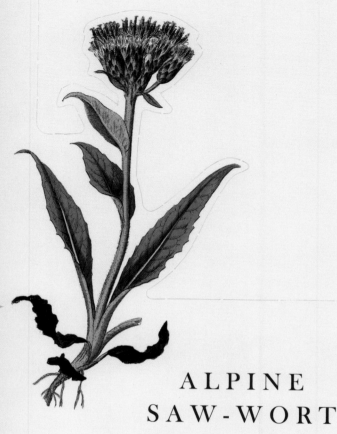

ALPINE
SAW-WORT

Saussurea alpina

---◆---

FAMILY: *Asteraceae (Daisy family)* **HEIGHT:** *3–18 in.*
FORM: *Herb* **NATIVE RANGE:** *Europe and Asia*

Four of the species in this book can be classified broadly as Arctic-alpines. They were chosen because they are such unexpectedly beautiful flowers to discover in the barren landscape of the Arctic tundra, on the gravelly, windswept slopes of high mountains—or in the carefully replicated mini-landscape of a backyard rockery! They are tough survivors, well adapted to their harsh environment.

In the wild, a blanket of snow often protects these species through the winter, but their growing season at high altitude or high latitude is

desperately short. The snows may not melt until early summer, and return as soon as fall sets in. There is often little soil for them to grow in, among the gravel and rocks, and they must work extra hard to attract the few pollinating insects that appear in the brief summer. That means Arctic-alpines can waste no energy on extravagant growth; instead, most are neat and compact.

Alpine Saw-wort is one of the more luxuriant and showy of these plants. It has broad saw-edged leaves, up to 6 inches in length and covered in grayish down on the underside, perhaps as a protection from frost. The flowerhead is made up of a cluster of tubular purple thistle-like flowers, protected by several rows of small floral leaves, called bracts, clasped tightly around the flowers, which are pollinated by flies and bees.

It is found throughout the tundra lands and mountains of Europe and Asia, reaching 75° North in Siberia and recorded to 9,200 feet in the Alps. However, its relative *Saussurea gnaphalodes* is in the record books as the highest known vascular (flowering) plant, discovered in 1938 by the mountaineer Eric Shipton at 21,000 feet above sea level on the world's highest mountain, Mount Everest.

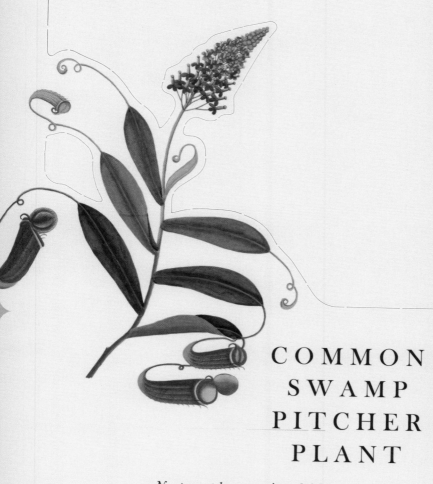

COMMON SWAMP PITCHER PLANT

Nepenthes mirabilis

---◆---

FAMILY: *Nepenthaceae*
FORM: *Herb*

HEIGHT: *20–80 in.*
NATIVE RANGE: *Southeast Asia to Australia*

The pitcher plant has a more sophisticated mechanism for feeding on insects than the large-flowered butterwort illustrated later in this book. There are around 85 species in the genus *Nepenthes*, mainly in Malaysia. A few of these have never been refound since their first discovery, and 10 species are confined to individual mountains in Asia.

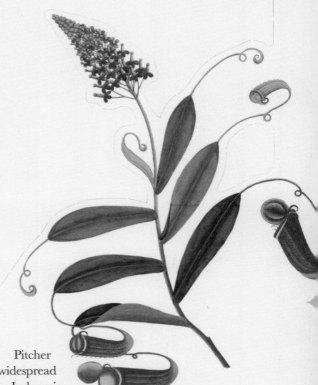

Common Swamp Pitcher Plant is by far the most widespread species, found in China, Indonesia, Malaysia, the Philippines, Papua New Guinea, and into the rainforests of Queensland in Australia. It thrives in forest shade, at altitudes up to 5,000 feet, even in habitats disturbed by human activities.

Like all pitcher plants, it obtains most of the nutrients it needs for growth by capturing prey. Initially the midribs protrude outward from the tips of some leaves and form small buds. These then expand into the pitcher-shaped traps shown in the artwork. Flying or crawling insects, such as flies, are attracted to the rim of the pitcher by the purple color and by glands that secrete nectar. When moistened, the rim becomes slippery, causing insects to fall into the trap. The smooth sides stop them climbing out, although pitchers typically capture less than one percent of visiting insects.

The pitcher is filled with rainwater—up to 3½ pints of it in the largest species. The plant secretes digestive juices into the pitcher pool, and these rapidly dissolve the trapped insect, releasing nutrients the plant needs for growth. However, some invertebrates and frogs seem immune to these digestive juices and can live in the liquid at the foot of the pitcher.

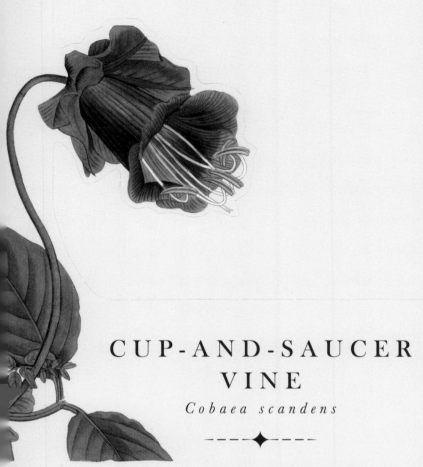

CUP-AND-SAUCER
VINE

Cobaea scandens

◆

FAMILY: *Polemoniaceae (Phlox family)*	**HEIGHT:** *10–40 ft.*
FORM: *Shrub*	**NATIVE RANGE:** *Tropical Americas*

Cup-and-saucer Vine earns its name from its beautiful nodding bell-shaped flowers (the cups), which are surrounded at their base by a saucer-like calyx (a united collar of green sepals). The flowers, which are up to 2 inches long, open white but turn purple as they mature. As befits such an ornamental plant, it has other evocative names, including Cathedral Bells, Monastery Bells, and Mexican Ivy.

It grows as a vigorous, rapid-growing, shrubby vine, which scrambles over other vegetation using twining tendrils that grow out from the midrib of its leaves. In its natural habitat in Mexico and tropical South America, its scrambling stems can reach 30 to 40 feet long. Gardeners

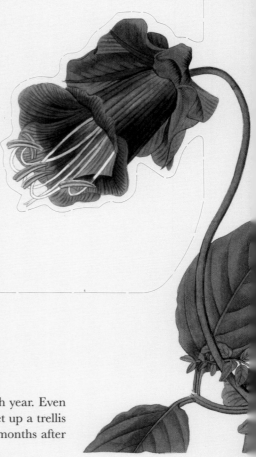

usually grow it afresh from seed each year. Even then, its stems can grow 10 to 20 feet up a trellis or fence by the time it flowers, five months after sowing.

The flowers open at or around sunset, and begin emitting a musky scent. This attracts bats, which sip the flower's nectar. As they probe the flower, the protruding stamens dust their furry chests with pollen, which they transport from plant to plant. Unlike some other bat-flowers, *Cobaea* flowers stay open for more than one night (up to four days, in fact) and by day they are often visited by hummingbirds (or flies in European backyards).

The genus name honors Father Bernardo Cobo (1572–1659), a Spanish Jesuit missionary and naturalist in Mexico and Peru, while *scandens* means "climbing." Charles Darwin, the naturalist who wrote *On The Origin of Species*, discussed the species in his book *The Movements and Habits of Climbing Plants* (1875). It has become a common weed around Auckland and Wellington in New Zealand, as a backyard escape.

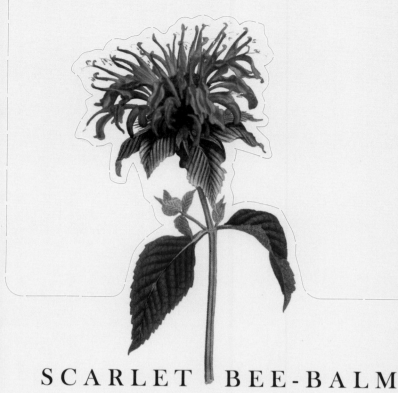

SCARLET BEE-BALM

Monarda didyma

--- --- ◆ --- ---

FAMILY: *Lamiaceae (Mint family)* **HEIGHT:** *24–60 in.*

FORM: *Herb* **NATIVE RANGE:** *Eastern United States*

This handsome flower is native to damp woodland in North America, from New York south to Georgia and west to Michigan. It is much planted in ornamental garden borders and has escaped from there into the wild in New England and New Jersey. Its tubular scarlet flowers attract hummingbirds and bees, which pollinate the flowers. It has also become established in the wild in parts of Europe and Asia.

Bee-balm has a long history of medicinal use by Native Americans. The Blackfeet Indians recognized the plant's strong antiseptic properties and used poultices from its leaves for skin infections and minor wounds. A herbal tea made from its leaves was used to treat mouth and throat

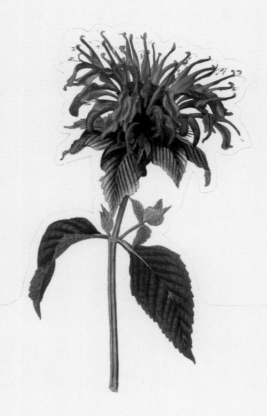

infections by the Oswego Indians of New York State, hence its alternative name of Oswego tea. After the Boston Tea Party stopped tea imports in 1773, bee-balm became popular as a tea substitute in New England.

Some of these medicinal uses were recorded in a herbal published in 1569 by the Spanish physician Nicolás Monardes, after whom the genus is named (*see also* Annual Sunflower). He noted that bee-balm smelled a little like bergamot, although oil of bergamot is extracted from the bergamot orange, *Citrus aurantium*, a native of Southeast Asia. The name bergamot is still used in America for the related species *Monarda fistulosa*, a native of the prairies of eastern Canada and the United States. Adding a fresh leaf of bee-balm to China tea will produce a taste reminiscent of Earl Gray tea, which is traditionally flavored with oil of bergamot.

Both this species and *M. fistulosa* (as well as other members of the Mint family) are sources of the antiseptic thymol, which is an active ingredient in many modern antiseptic mouthwashes.

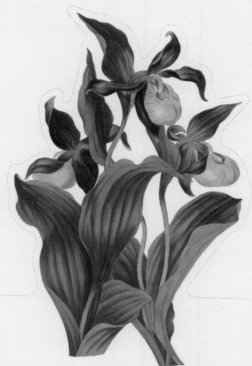

LADY'S SLIPPER ORCHID

Cypripedium calceolus

◆

FAMILY: *Orchidaceae*
FORM: *Herb*

HEIGHT: *8–20 in.*
NATIVE RANGE: *Europe and parts of Asia*

The Lady's Slipper is the most beautiful of all European orchids, found on lime-rich soils in open woods, from northern Greece to well north of the Arctic Circle in Scandinavia. It is hardy in backyards, but difficult to establish from seed. Specimens in many historic gardens were originally collected from the wild, although this is now forbidden over most of its range.

Orchid flowers consist of three outer "perianth segments" (replacing sepals) and three inner perianth segments (like petals). All of them are colorful, but the lowest inner one, called the lip, is often developed into an elaborate form relating to pollination.

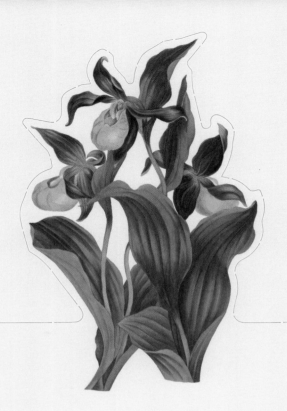

This is especially true of the Lady's Slipper, in which the lower lip is inflated into a yellow slipper-like pouch, surrounded by five twisted, brownish-purple perianth segments. The inside of the lip is smooth, except for lines of stubbly hairs leading upward from the pouch base. Transparent folds on each side of the lip act as windows for light.

The flower's sweet scent attracts bees. When these land on the slippery lip, they lose their foothold and fall into the pouch. The two "windows" highlight the exit, and the lines of hairs offer an escape route, but they guide the bees past the stamens, which dust pollen onto their backs. When they visit the next flower, this pollen brushes onto the orchid's stigma and pollination is completed.

Over-collection in England reduced the species by 1930 to a single clump at one secret site in Yorkshire. This clump was carefully guarded, and its flowers were pollinated by hand to ensure they set seed. Seedlings grown in test tubes have been planted into 12 other suitable sites, but the species is still regarded as "critically endangered" in Britain.

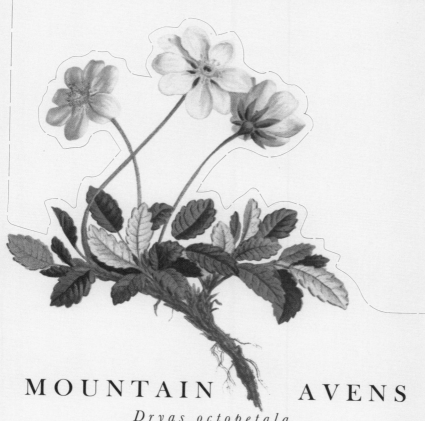

MOUNTAIN AVENS

Dryas octopetala

— — — ◆ — — —

FAMILY: *Rosaceae (Rose family)*
FORM: *Shrub*

HEIGHT: *10–20 in.*
NATIVE RANGE: *Europe, Asia, and North America*

Scientific names of species are intended as a definitive international epithet that transcends languages and country boundaries. They are often prosaic, sometimes deeply obscure, and occasionally richly descriptive, like *Dryas octopetala*. The genus name recalls the dryads or oak fairies, a reference to the crinkled edges of the leaves, which somewhat resemble those of oak trees. *Octopetala* means "eight-petaled," and these two features perfectly characterize the distinguishing features of the species.

Mountain Avens is a creeping dwarf shrub, which is to say that it has woody stems but these rarely reach much above ankle height. It forms dense

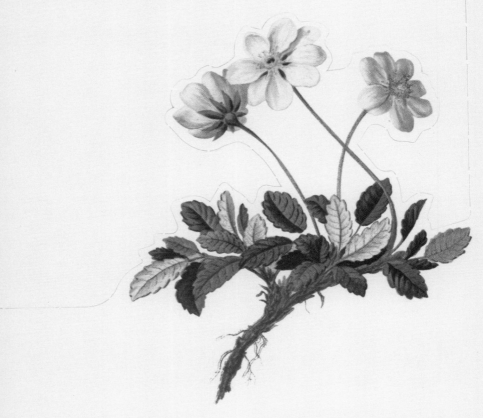

patches of leaves that are deep green, strongly veined, and rather glossy on their top surface, with a white felt of hairs on the underside. Its showy, solitary flowers are up to 1½ inches in diameter, usually with eight (but occasionally ten) overlapping creamy-white petals, and a cluster of yellow pollen-producing stamens in their center.

Time-lapse photography shows that the flower stems twist to track the sun as it moves across the sky in summer, like a miniature telescope. It is thought this warms the flowers, helping them to emit their scent better and making them more attractive to visiting insects that pollinate the flowers. The clustered fruits that then develop are each topped with a long, twisted plume, which acts as a parachute to disperse them in the wind.

Mountain Avens grows in lime-rich areas in mountains across Europe, southern Asia, and North America from Alaska and Newfoundland south to the Rocky Mountains. It is also found across the arctic regions of the world, sometimes forming a dense turf on hillsides where snow remains late in the season. It is the national flower of Iceland.

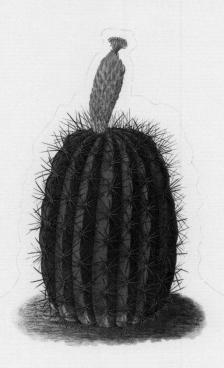

RED-SPINED
BARREL CACTUS

Denmoza rhodocantha

--- --- ◆ --- ---

FAMILY: *Cactaceae* **HEIGHT:** *8–157 in.*
FORM: *Herb* **NATIVE RANGE:** *Argentina*

Originally painted under the scientific name *Echinopsis rhodocantha*, this is a cactus with a double life—so much so that it was once thought to be two separate species. Like many cacti, it has a swollen stem covered in spines, hence *Echinopsis*, translated as "like a hedgehog," and *rhodocantha*, meaning "red-spined."

The plant is widespread in the mountains of Argentina, at altitudes of 2,600 to 9,200 feet. It is slow-growing, and can live for more than 100

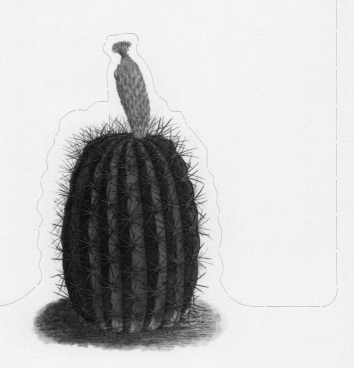

years. In its early life, it has a barrel-like form with red spines, but it then slowly grows into a more columnar shape, reaching 13 feet in height. These older plants are covered in grayish-white, bristly spines up to 2½ inches long. Initially, scientists did not realize that one form turned into the other, so the older cacti were regarded as a different species.

From a few years old, the plants produce tubular scarlet-colored flowers, up to 3 inches long. These are scentless but produce plentiful nectar. From the shape and color of the flowers, it was assumed that they were pollinated by hummingbirds, like many other cacti in the area.

Recently, some dedicated botanists spent hours watching a group of plants, but never once saw hummingbirds visiting the flowers. Instead, they regularly observed bees crawling over them. Some were carrying violet-colored pollen, typical of the species, so they were probably regularly visiting the flowers to feed on pollen, and, in the process, would have pollinated them. The botanists suggested that the long spines around the flowers probably discourage hummingbirds from approaching.

The new genus name, *Denmoza*, rather prosaically, is an anagram of the Argentinean province Mendoza, a happy hunting ground for cactus-lovers where the species is common.

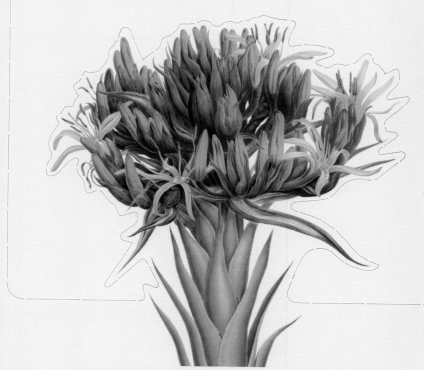

GYMEA LILY

Doryanthus excelsa

◆

FAMILY: *Agavaceae (Agave family)* **HEIGHT:** *6–16 ft.*

FORM: *Herb* **NATIVE RANGE:** *Australia*

The district around Sydney in New South Wales is one of the richest floristically in Australia, with around 2,000 native species recorded. It is characterized by hot summers, often with long dry periods that stimulate regular bushfires, but is usually free of winter frosts except in the mountains.

Gymea Lily is adapted to these conditions. It is drought-tolerant, thanks to its thick sword-shaped leaves which spread outward in a rosette from its roots. The leaves channel any moisture that lands on them down toward the plant's center to refresh the roots. After fires, the plant regrows quickly from its roots.

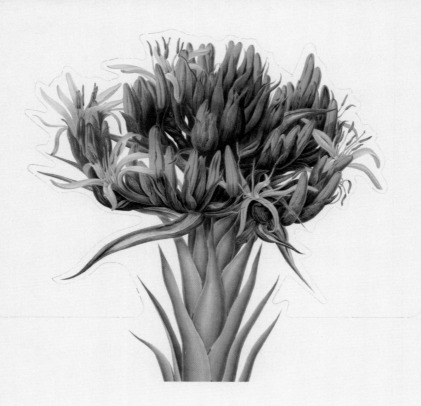

A tall, leafy flowerstalk grows upward from the leaf rosette, topped by dense clusters of dark-red flowers. That makes it one of the most conspicuous of local plants, and earns it the names of Giant Lily, Flame Lily, or Spear Lily. The generic name *Doryanthus* also translates from the Greek as "spear flower," while *excelsa* means "high" or "lofty" in Latin. The flowers are rich in sweet, syrupy nectar, and attract honeyeaters and other nectar-loving birds.

Such a dramatic plant inevitably has a strong place in local culture. Indigenous Australians used to roast the stems and roots, and make the roots into a kind of cake that was eaten cold. Today, the Sydney suburbs of Gymea and Gymea Bay are named after the plant.

Many native Australian plants are very resistant to being moved, but Gymea Lily readily survives being dug up and transplanted for landscape-gardening projects, not just around Sydney but also in other coastal areas such as Brisbane and Perth. However, in the absence of fires, it can take four to ten years before it flowers.

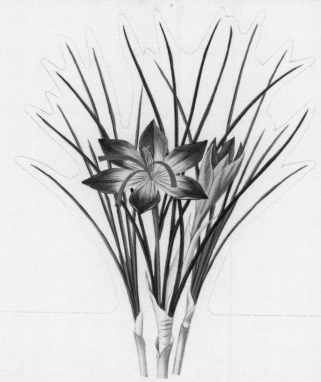

SAFFRON CROCUS

Crocus sativus

--- ◆ ---

FAMILY: *Iridaceae (Iris family)* **HEIGHT:** *4–6 in.*
FORM: *Herb* **NATIVE RANGE:** *Unknown*

Saffron is the most expensive spice in the world, yet the wild origins of the crocus from which it is extracted are lost in the mists of time. Most probably it originated in Turkey or the Middle East. The production of saffron is first recorded from Mesopotamia around 5,300 years ago, and by the Middle Ages cultivation of the plant had spread all round southern Europe and Asia.

Used as a reddish-yellow food dye, saffron's pungent, bitter taste helps flavor cheeses, butter, pastry, and confectionery. It provides the color and earthy taste in Spanish *paella* and French *bouillabaisse*.

The spice is extracted from the three long red styles in the center

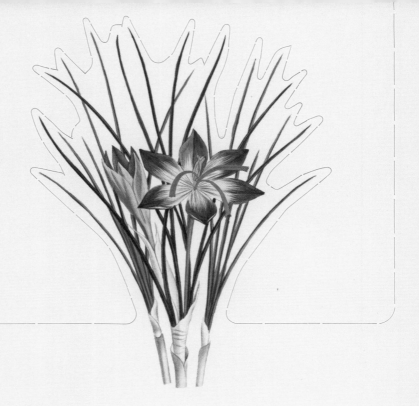

of the delicate lilac flowers. At the tip of the style, the stigma is the receptive surface which catches pollen from visiting insects. A pollen tube then grows down the style to the ovary, where it fertilizes an ovule so that a seed can develop. It takes more than 450 dried and toasted styles (called "threads" in cultivation) from 150 crocus plants to produce a single gram of saffron, hence the high cost, typically around $6 per gram, but over $8 for the highest-quality grades.

Saffron Crocus is grown as a commercial crop mainly in Spain, Greece, Turkey, Egypt, Iran, and Kashmir. It is also one of 20 or so crocus species that are widely grown in backyards for ornament. They are grown from corms (short, erect, swollen underground stems) and produce a cluster of strap-shaped leaves, marked by a central white line. Unusually this species flowers in fall—presumably thereby ensuring that its wild ancestors could attract, as pollinators, moth species that only emerge from their chrysalises in late summer.

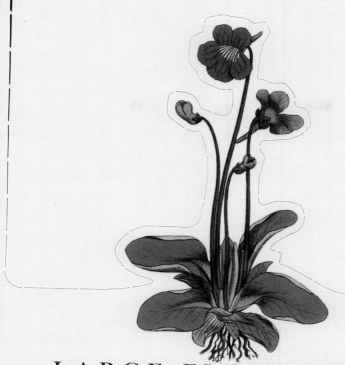

LARGE-FLOWERED BUTTERWORT

Pinguicula grandiflora

--- ◆ ---

FAMILY: *Lentibulariaceae*
(Butterwort family)
FORM: *Herb*

HEIGHT: *2½–8 in.*
NATIVE RANGE: *Southwest Europe*

Bogs are challenging places for plants to grow. They are wetlands, mainly fed by rainfall, in which peat accumulates. Peat forms from the partially decayed remains of bog mosses, but this process releases acids. As a result, bogs have acid levels that are toxic to many plants and are desperately short in the nutrients that plants need to grow. One way some bog plants get around this problem is by trapping small creatures, mainly insects.

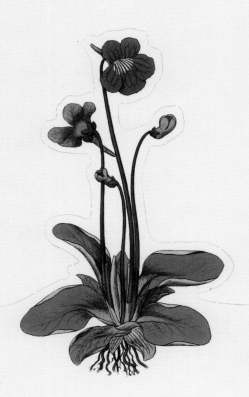

Butterworts are one group of insectivorous plants, found in bogs from north-temperate regions south to Tierra del Fuego at the tip of South America. They produce rosettes of oblong leaves, just above the peat. The upper surfaces of their leaves are covered in glands which secrete a sticky fluid. The resulting shininess makes the leaves look like melting butter, hence their name. It has been calculated that a typical butterwort leaf rosette contains more than half a million of these glands.

Small insects, attracted by the gloss, land on the leaf and become stuck. Their struggle to escape makes the edges of the leaf curl over, which stops the insect being blown away. This also nudges the trapped insect towards the center of the leaf, where there are more glands; these secrete powerful digestive juices which rapidly dissolve the insect. The leaf then absorbs the nutrients, which help the plant to grow.

Large-leaved Butterwort is one of the larger species, with showy violet-blue or purple flowers. It is found in bogs in southwest Europe from the Cordillera Cantabrica of Spain to the Swiss Jura mountains, including southwest Ireland from County Cork to County Clare, but not Britain.

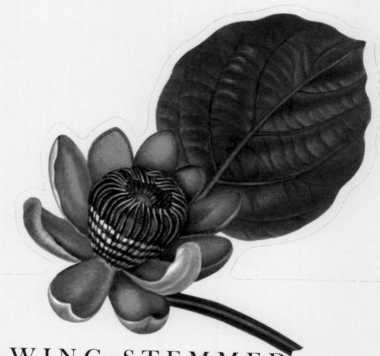

WING-STEMMED
PASSION FLOWER
Passiflora alata

------◆------

FAMILY: *Passifloraceae* **HEIGHT:** *10–20 ft.*
FORM: *Shrub* **NATIVE RANGE:** *Peru and Brazil*

All the 500 or so species of passion flower grow as vines—shrubs that scramble or climb over other plants because their weak, woody stems cannot stand upright by themselves. They are found throughout the tropics and subtropics, although a few extend into temperate regions.

The Wing-stemmed Passion Flower is native to the Amazonian rainforest of Peru and eastern Brazil. It is also cultivated commercially in Brazil for its scented, edible fruit, known as a fragrant granadilla, which is yellow to bright orange, and egg-shaped. Its stems are square in section,

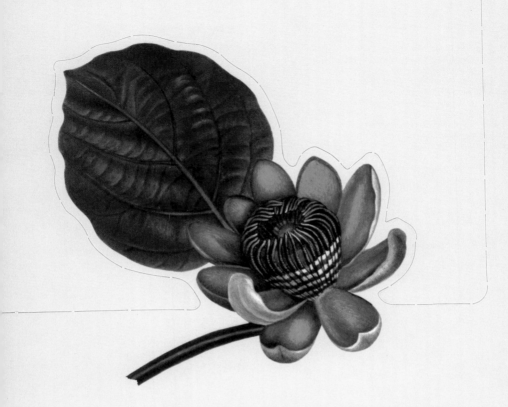

but the corners extend into wings, hence its common name. Its leathery oval leaves are 3–6 inches long and offer an attractive year-round display in tropical backyards, although in temperate regions the species must be grown indoors. The plant clings to vegetation—or to trellised fences—by coiled, wiry tendrils that grow from the base of the leafstalks.

For gardeners, the main attraction is the dramatic, pendulous flowers, $2^3/_4$–4 inches across. These have five purple sepals, which are slightly smaller than but otherwise identical to five purple petals. In the center is a crown-like corona, made up of several rows of narrow, upright filaments, banded purple and white. This forms a protective fringe around the pollen-producing stamens and the receptive styles in the center of the flower. In Christian iconography, the sepals and petals represent ten apostles (without Peter and Judas), the corona represents the crown of thorns, the three styles are the nails attaching Christ to the cross, and the five stamens represent his wounds—hence the name "passion flower."

The flowers are visited by butterflies, especially long-winged butterflies in the genus *Heliconius*, which pollinate them.

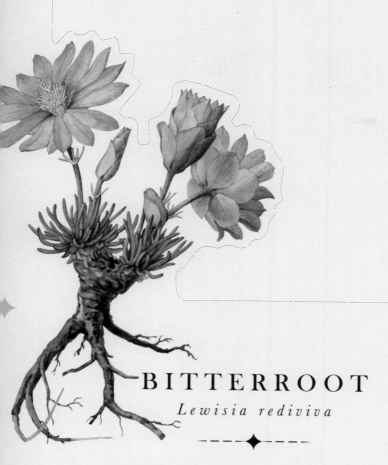

BITTERROOT

Lewisia rediviva

FAMILY: *Portulacaceae*
(Purslane family)
FORM: *Herb*

HEIGHT: *1¼−4 in.*
NATIVE RANGE: *Western United States*

In 1803, the United States purchased a large tract of land beyond the Mississippi River from the French for around $11 million. Shortly afterward, President Thomas Jefferson commissioned an expedition to cross the area, from St. Louis in Missouri to the Pacific coast. The main objective of this Lewis and Clark Expedition, named after its leaders, was to find a practical route across the western half of the continent, but an additional aim was to study the area's plants and wildlife.

Bitterroot was one of the plants they found, and it was given the name *Lewisia* to commemorate the expedition's commander, Captain

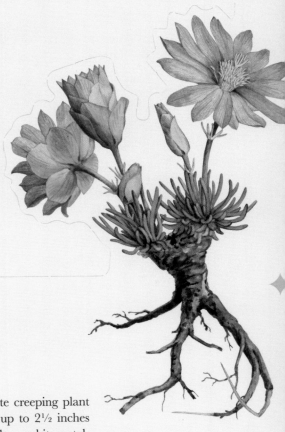

Meriwether Lewis. This delicate creeping plant has surprisingly large flowers, up to 2½ inches in diameter, with six deep-pink or white petal-like sepals and six similar petals. It is found down the west coast of North America from British Columbia to southern California, and inland to Colorado and Montana, where it is so abundant that it was chosen as the Montana state flower. It is recorded at altitudes up to 11,000 feet in the mountains—and Lewis himself named the Bitterroot Mountains between Montana and Idaho after the plant.

Lewis noted that, even if the plant was dried out as a herbarium specimen, it could be revived in water and begin to grow once more. In fact, a dried specimen he sent to Kew Gardens in London was restored to life after 18 months in transit—hence the specific name *rediviva*, "revived." Local Native American tribes ate the plant's roots after first soaking off the bitter bark in water (thus "bitter-root"). It was also called "tobacco-root" from the tobacco-like odor of these boiled roots.

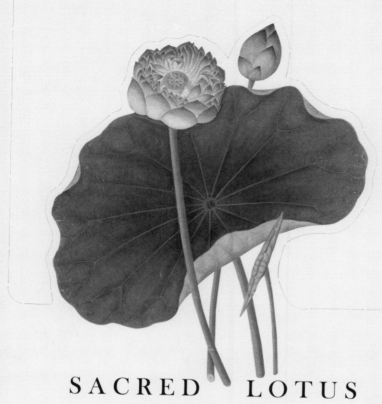

SACRED LOTUS

Nelumbo nucifera

◆ — — —

FAMILY: *Nelumbonaceae*
FORM: *Herb*

HEIGHT: *35–60 in.*
NATIVE RANGE: *East Asia and Australia*

As its name implies, this beautiful water plant is regarded as sacred by Hindus and Buddhists in India and elsewhere. Hindus revere it in association with the god Vishnu, who is often portrayed in iconography standing on a pink lotus. For Buddhists, it represents purity of body, speech, and mind, perhaps inspired by the way its flowers and leaves float above muddy river waters.

Sacred Lotus is a marginal water plant, rooting in the mud at the foot of ponds and slow-flowing rivers in tropical and subtropical East Asia. Its stems can reach the surface in waters up to about

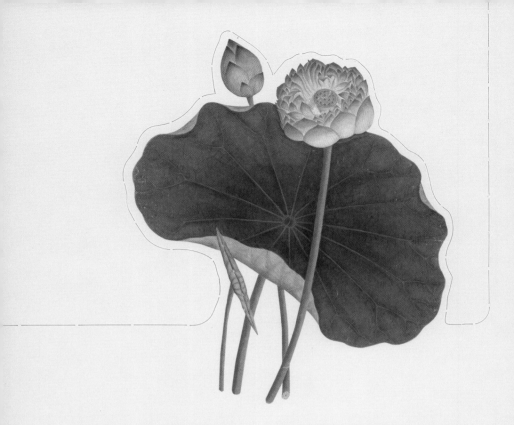

5 feet deep, where they develop large, floating leaves shaped like dinner plates.

The flowers rise above the leaves, with two to five pink sepals and 20 to 30 spirally arranged petals, which are usually a vivid rose-pink color, turning more flesh-pink as the flowers mature, but are sometimes white. After fertilization, these develop into a fruit, shaped like the rose of a garden watering can, with a single large seed called a "nutlet" protruding from each hollow on its surface. The seeds are longlived, and can germinate even after 1,300 years.

The species is widely cultivated in Asia for its ornamental leaves and flowers, but also because its tubers and rhizomes are buried in the mud, its young leaves and nutlets are all highly edible. It is probably native also to coastal lagoons in tropical Queensland and elsewhere in eastern Australia, but its overall range is confused by plants escaped from cultivation, including in North America. However, there is also a native species there, called American lotus, *Nelumbo lutea*, which grows extensively along the Mississippi River and elsewhere in the eastern United States.

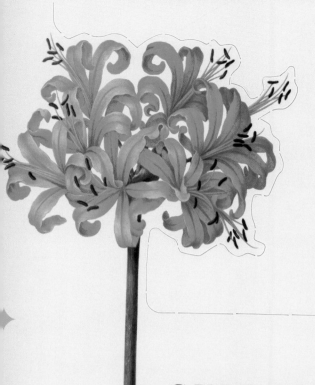

GUERNSEY LILY

Nerine sarniensis

— – – ◆ – – —

FAMILY: *Liliaceae*
FORM: *Herb*
HEIGHT: *6–18 in.*
NATIVE RANGE: *South Africa*

Guernsey Lily was once cultivated under glass for the cut-flower trade on the British Channel Islands from which it takes its name. That trade has almost disappeared, but the species is still grown by local gardeners and celebrated on the island in an annual Nerine Festival in October.

How the plant reached Guernsey is a mystery. In 1680, Robert Morison, Professor of Botany at Oxford University, described how a ship from the Dutch East India Company, carrying boxes of bulbs of the plant from Japan, destined for Holland, was shipwrecked on the island in a storm

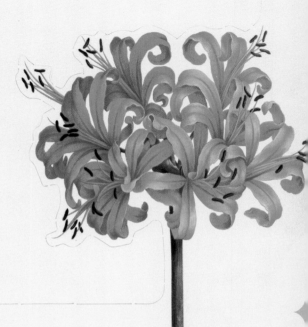

in 1659. To the islanders' astonishment, a few years later, beautiful red flowers of the lily appeared in the sand dunes and have been propagated there ever since.

Linnaeus, the Swedish naturalist who established the modern scientific system of naming plants and animals, accepted the story and named the species *Amaryllis sarniensis*, after Sarnia, the Roman name for Guernsey. In 1820, inspired by the same story, the genus was renamed *Nerine*, to honor a mythical sea nymph.

In truth, bulbs are unlikely to germinate after being drenched in seawater, and no shipwreck is recorded on Guernsey during this period in shipping archives. The species, thought to have come from Japan, was recorded in a Paris garden in 1634, and was most probably taken from there to Guernsey, which has always had strong French links. In the late 1650s, bulbs were imported from Guernsey into England.

Then, around 1780, plants were discovered on Table Mountain above Cape Town. We now know that the species is native to rocky mountain slopes in the southwestern Cape Province of South Africa, although its population on Table Mountain has declined due to over-collection.

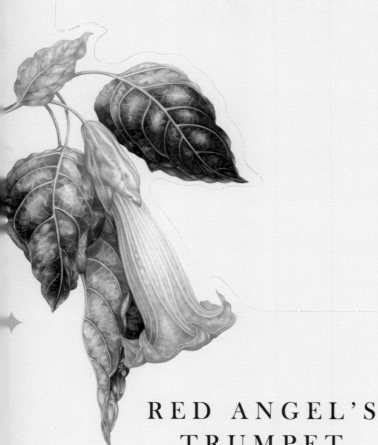

RED ANGEL'S TRUMPET

Brugmansia sanguinea

❖

FAMILY: *Solanaceae (Potato family)*

FORM: *Tree*

HEIGHT: *16–33 ft.*

NATIVE RANGE: *Colombia to Chile*

The delicate blossom in the artwork was painted from a garden specimen brought from Ecuador. It is labeled as *Datura rosei*, but botanists have changed its name because it appears not to be closely related to thorn apple *Datura stramonium*, a native of North America that is widely established in old gardens in Europe. Unlike *Datura* species, the seven species of *Brugmansia* are trees or shrubs, not bushy herbs; they have nodding rather than upright flowers, and have no spines on their fruits.

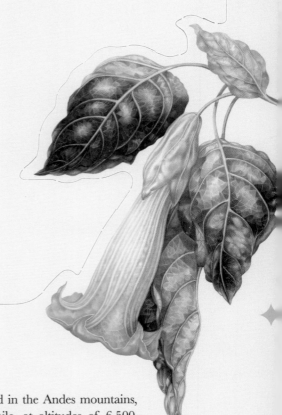

Red Angel's Trumpet is found in the Andes mountains, from Colombia to northern Chile, at altitudes of 6,500–11,000 feet. It is only found near houses, roads, and fences, with no records of truly wild plants, and seems to rely entirely on humans for its survival. Although it produces copious seeds, it may be that whichever animals naturally dispersed the seeds are now extinct.

Most *Brugmansia* species are fragrant in the evenings to attract pollinating moths, but this species is scentless, and is thought to rely on longbilled hummingbirds for pollination. Birds are particularly attracted by red colors, which explains why it mainly has red flowers, or flowers in various shades of yellow, orange, or green with a conspicuous red rim.

As with many other members of the Potato family, most parts of *Brugmansia* plants are poisonous (even potatoes are poisonous if still green). However, leaves of Red Angel's Trumpet have been used medicinally and spiritually, in carefully controlled quantities, by indigenous native healers in South America. Today, with declining numbers of expert healers, plants are being eradicated from backyards for fear of their toxicity, and the species could be endangered without continuing human intervention.

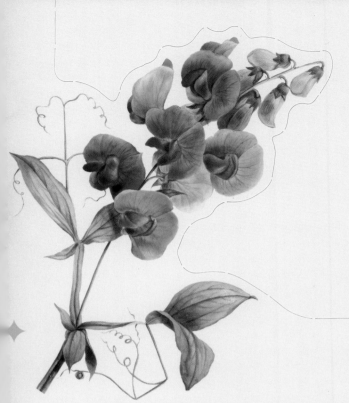

BROAD-LEAVED
EVERLASTING PEA

Lathyrus latifolius

------◆------

FAMILY: *Leguminosae (Pea family)*
FORM: *Herb*

HEIGHT: *2–10 ft.*
NATIVE RANGE: *Central and southern Europe*

From Greece to northern France, this vigorous climbing plant is found in hedgerows, fields, vineyards, and uncultivated ground. It is often grown as an ornamental in gardens and can escape from there and become "naturalized," so that it appears truly wild. In Britain, for example, it was first recorded as a backyard escape in 1670, and now turns up regularly along railway embankments and scrambling over old walls, especially

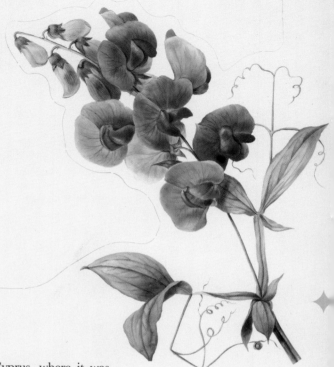

around London. In Cyprus, where it was
introduced, it is recorded to altitudes of
5,000 feet in the Troödos Mountains. As a backyard escape, it also occurs
elsewhere in parts of Europe, North America, and Australia.

Its stems are robust, but not strong enough to stand independently, so
it must always scramble over other vegetation, walls, or fences. The leaves
consist of two, narrow leaflets with a branching tendril between them that
reaches out to support the plant as it scrambles.

For gardeners, of course, the flowers are the main attraction:
elongated clusters of 5 to 15 typical pea flowers, magenta-purple or pink
in color and up to an inch across. These have a large flag-like upper
petal, called a "standard;" two smaller lateral petals, called "wings;"
and two lower petals that are fused together as a "keel," which conceals
the inner workings of the flower. Only a bee is heavy enough to open
the flower when it lands on the keel in search of nectar. In the
process, the flower brushes pollen onto the bee's back, which it carries
to another flower for pollination. The fertilized flower develops into a
green fruiting pod, and then turns brown as it ripens, ultimately splitting
explosively to propel the seeds outward.